Keith Roberts

BRUEGEL

Phaidon

Phaidon Press Limited, 5 Cromwell Place, London SW7

Published in the United States by Phaidon Publishers, Inc
and distributed by Praeger Publishers, Inc
111 Fourth Avenue, New York, N.Y. 10003

First published 1971

ISBN 0 7148 1480 6
Library of Congress Catalog Card Number : 73-141057

Text printed in Great Britain by R. & R. Clark Limited,
Edinburgh
Plates printed in Austria by Druckerei Brüder Rosenbaum,
Vienna

A HUNDRED YEARS AGO it would not have been possible to buy a book on Pieter Bruegel; none existed. And even had there been one available, few purchasers would have been found. Although the French critic Bürger-Thoré—the re-discoverer of Vermeer—could write in 1862 that Bruegel was 'a true master whose importance is under-estimated', most people of taste would have echoed the disapproving tones of the German art historian, G. F. Waagen, who wrote in 1869: 'His mode of viewing these scenes [of peasant life] is always clever but coarse; and even sometimes vulgar.' That the climate of critical opinion has changed drastically is demonstrated, in a modest fashion, by the existence of the book that you are now reading, one of a low-priced series in which only the most celebrated popular artists can be included.

There are two main reasons for this shift in Bruegel's critical fortunes. The first is linked to the greater degree of tolerance that has characterized our aesthetic responses since the middle of the nineteenth century. We are prepared to look at the arts of different periods and cultures with a lack of prejudice that would have astonished (and slightly appalled) a connoisseur of the mid-Victorian age. Waagen himself was a man of traditional, somewhat exclusive taste who worshipped the pictures of that master of idealized images, Raphael. We are also less prudish, and the frankness of much of Bruegel's imagery, a source of embarrassment to the Victorians, presents few problems to a generation that is not over-anxious about decorum. This loosening of critical bonds has in turn encouraged scholars to work on Bruegel and fill in, and in many places correct, the shadowy outlines of life and reputation that were all that were generally known. We can now be sure, for instance, that Bruegel was not himself a simple peasant, as nineteenth-century critics still believed, but a cultured man in contact with some of the best minds of the day. But although we know more about him than ever before, Bruegel remains, by twentieth-century standards of veracity, as dim and shadowy—and in many ways as ambiguous—a figure as Shakespeare.

The second reason for Bruegel's great modern reputation is connected with the development of photographic reproduction. Lest this sound ungallant, it should be recalled that he is not an artist with a central towering masterpiece that has become a focus of cultural pilgrimage, like Michelangelo's *Sistine Ceiling*, nor is he a painter, like Rembrandt, Cézanne or Renoir, with a large output generously scattered through the galleries of Europe and America. His surviving pictures are few in number—under fifty—and not always conveniently located. Of the five in Great Britain, the most easily accessible, the National Gallery's *Adoration of the Magi* (Plate 21), is not representative of his finest manner, while the Hampton Court version of *The Massacre of the Innocents* (for the Vienna version, see Plate 34) is damaged and distorted by overpaint to an apparently irrevocable degree. Two are privately owned in London and the fifth, the magnificent *Death of the Virgin* (Plate 30), which once belonged to Rubens, is in a National Trust house near Banbury. Germany can claim five publicly exhibited works, the United States

three. Only in Vienna, which has fourteen paintings, can Bruegel be fully appreciated.

But it is unlikely that everyone who cares for his work has been there. What they have been brought up on are reproductions, which are often very good precisely because Bruegel's paintings, with their sharp outlines and clear, simple colours, reproduce well. With the work of many great artists, photography, as a passport to mass popularity, has been a tragically mixed blessing. The average colour reproduction of an El Greco bears as much relation to what the artist intended, and painted, as the first rehearsal of the *Jupiter Symphony* by an amateur orchestra represents what Mozart wanted the world to hear. With Bruegel, however, the loss is not quite as great. He does not depend, to such an extent, on subtleties of colour, and he filled his pictures with tiny figures and incidents that lend themselves to exclusive inspection in isolated details. As early as 1604, the painter-historian, Carel van Mander, touched on this aspect of Bruegel's art when he described 'a *Massacre of the Innocents* [probably the Hampton Court version], in which we find much to look at that is true to life . . .: a whole family begging for the life of a peasant child which one of the murderous soldiers has seized in order to kill, the mothers are fainting in their grief, and there are other scenes all rendered convincingly.'

The fact that an artist's work reproduces well need only have a bearing on its character, not its quality. Equally, the capacity to appreciate what was despised in an earlier age may indicate no more than an indiscriminate hungering after mere novelty and sensation. But Bruegel's reputation is not founded on shifting sand: he is a great artist whichever way you look at him, in his own milieu, where he can confidently be claimed as the most profound painter to emerge in Flanders in the century and a half that divides the age of Jan van Eyck from that of Rubens, and in absolute terms as well.

The quality of Bruegel's work puts him on a level with Van Eyck and Rubens; but its character and the orientation of his career serve rather to separate him from them. Unlike his great compatriots, Bruegel held no positions at court, he did not produce altar-pieces for churches and he did not paint portraits—which is hardly surprising in view of his unflattering style. Van Eyck, master of a style hitherto unparalleled in the range of its naturalistic effects, and Rubens, the leading pioneer and greatest exponent of the Baroque idiom in Northern Europe, were both in their different ways revolutionary artists. Though influential, Bruegel was not. If *The Procession to Calvary* (Plate 13), *The Peasant Dance* (Plate 41) or *The Gloomy Day* (Plate 22) seem highly original, this is essentially a tribute to their quality rather than their character. A strong archaic element runs through Bruegel's paintings, drawings and prints, and it is not only expressed in design—*The Procession to Calvary*, for example, goes back to an Eyckian pattern—but also revealed, more significantly, in the fundamental approach to art itself. Bruegel's vision—the suggestion of a world in miniature; the passion for endless detail; the abrupt contrasts between the literal and the fantastic; the mixture of brutality, licentiousness and guilt—his whole way of seeing things belongs to the dying Middle Ages. Even the seemingly straightforward seasonal landscapes (Plates 22, 24, 35) belong to a systematized, descriptive tradition that had its direct roots in mediaeval illumin-

4

ated manuscripts. From one point of view, Pieter Bruegel can be regarded as the last great mediaeval painter.

Bruegel was not concerned with achieving an illusionistic degree of finish, an attitude which set him apart from most of his contemporaries; and he did not share that interest in idealized figures that was becoming increasingly fashionable in sixteenth-century Flanders and which Rubens was to make one of the cornerstones of his art. Bruegel was indifferent to the concept of ideal beauty, and was incapable of realizing it in an acceptable manner when its presence was obviously indicated. Who would imagine, on being confronted by the sly, hooded mother and her elderly child receiving homage from the enfeebled fanatic who kneels before her, that this was meant to represent the *Adoration of the Magi* (Plate 21), a crucial moment in the history of the Christian Faith? The painting is grotesque to the point of parody—which was certainly not the intention: there is no evidence to suggest that Bruegel was anything but an orthodox Roman Catholic who worked for like-minded patrons. The point is even more clearly made in *The Procession to Calvary* (Plate 13). It is impossible to look at this picture for long without being struck by the great difference in style between the main part of the scene and the Holy Figures at the bottom. They are of a type common in Flemish painting a hundred years earlier. The implication is clear. Incapable of creating for himself suitably idealized sacred images, Bruegel was reduced to aping the style of a previous age, which gave his Holy Figures (the three Maries and St John the Evangelist) a remote and, by extension, pious air.

Although Bruegel was famous in his own lifetime, the archaic tone of much of his imagery and his refusal to adopt the idealized figure style evolved by Italian Renaissance artists had, in sophisticated circles, an adverse effect on his reputation both during his life and after his death. His works did not conform to current aesthetic theories, with the result that the still primitive historical sense of early writers on art was not stimulated to any illuminating degree by his career. There was no one to interview him, and to record his thoughts on art—as happened in the case of Michelangelo—and if he wrote any letters, none survive.

Even the date and place of Bruegel's birth are uncertain, although the general consensus of opinion is that he was born near Breda about 1525. According to Carel van Mander, the painter-historian who included a life of Bruegel in his *Schilderboek* published in 1604, the young Bruegel was apprenticed to Pieter Coeck van Aelst, a successful Italianizing artist who maintained studios in Antwerp and in Brussels, where he died in December, 1550. To modern eyes, Coeck's work is not particularly sympathetic, but that does not mean that it could not have influenced the greater artist at a time when he was a young and impressionable studio apprentice. Bruegel certainly knew Coeck's series of wood-cuts illustrating Turkish life and manners, which were based on drawings made in 1533 (posthumously published in 1553). They look slightly absurd now, but with their rich store of exotic facts, they may well have created in Bruegel's mind the same impression, of the strange made familiar by virtue of circumstantial detail, that we receive from his own later *Tower of Babel* (Plate 12). In both cases, it is as well to remember that the sense of evidence in the sixteenth century was more naive and irrational than our own. In a period when scientific investigation was in its infancy (when it

was not being banned altogether by the religious authorities) and when faith itself was often counted a part of knowledge, witches were a definite possibility, even a fact. Shakespeare's assumptions as to what his audience would accept as credible are in this respect extremely revealing. It is this sense of fact, permeated by religious faith, which gives to even Bruegel's most bizarre creations—The 'Dulle Griet' (Plate 4), for example, or The Triumph of Death (Plate 6)—their curiously objective character. This, Bruegel seems to be showing us, is how it is—in the light of day.

In 1551, Bruegel became a Master of the Antwerp Guild, an indication that he had finished his training satisfactorily and was fit to set up a studio on his own. In 1552, 1553 and possibly for part of 1554, he travelled abroad. In 1552, he was in the south of Italy, visiting Reggio Calabria, Messina, Palermo and.Naples, and in the following year he was in Rome, where he came into contact with a well-known painter and miniaturist of the day, Giulio Clovio (later a friend of El Greco), who acquired a number of his works (now lost) done at this time. These included a View of Lyons painted in water-colours—a technique Bruegel may have learned from Pieter Coeck van Aelst's wife, Mayken Verhulst Bessemers, who was a specialist in the medium. That he was familiar with the water-colour technique is evident from his paintings, where the oil medium is used with the same degree of delicacy and transparency. The late pictures on canvas, The Parable of the Blind (Plate 45) and The Misanthrope (Plate 48a), show this particularly well. The View of Lyons and a miniature of The Tower of Babel that Clovio also owned imply that Bruegel was already concentrating on landscape, a deduction corroborated by an extensive series of drawings of the Alps that he made on this journey.

On his return to Flanders, Bruegel began to work for the Antwerp engraver and print-seller, Hieronymus Cock. The Alpine sketches that he had made formed the basis of a number of elaborate landscape designs (dated from 1555 onwards) which were actually engraved by other artists. Cock was presumably pleased with Bruegel's work for he was soon employing him on figure compositions as well. Of these, the series of The Seven Deadly Sins (1556–7) and the famous Big Fish eat Little Fish are typical early examples. Like most of Bruegel's work, they deftly combine entertainment with serious moral instruction. The style is—and was intended to be—consciously reminiscent of the art of Hieronymus Bosch (active 1480/1––died 1516). Cock had already been very successful with prints of Bosch's designs, and it is interesting to note that while the composition of Big Fish eat Little Fish is definitely by Bruegel (there is an authentic preparatory drawing, now in Rotterdam, signed by him and dated 1556), the engraving was first issued under Bosch's name. The connection between the two artists was recognized by contemporaries: a Latin epigram of 1572 refers to Bruegel as 'this new Hieronymus Bosch'.

For the rest of his life Bruegel was active both as a painter and designer of prints, and the two activities were closely linked. The same theme sufficed for both media. The engraved Alpine landscapes of the later 1550s can be compared with paintings like the Parable of the Sower (1557. San Diego, California, Timken Art Gallery), and prints such as the Seven Deadly Sins series with The 'Dulle Griet' (Plate 4).

In 1563, Bruegel married Mayken, the daughter of his old teacher, Pieter Coeck

van Aelst. The couple went to live in Brussels, where the painter died in 1569, probably still only in his mid-forties. During the last six years of his life, Bruegel was much influenced by Italian Renaissance art, whose monumentality of form he found increasingly sympathetic. This influence is evident in the *Peasant Wedding* (Plate 40), *The Peasant Dance* (Plate 41) and *The Peasant and the Birdnester* (Plate 37), especially when they are compared with earlier pictures like *The Triumph of Death* (Plate 6): the figures are now larger in scale and closer to the spectator, the viewpoint is lower and there is less concern with the setting.

In spite of these radical developments, however, Bruegel continued to produce paintings in his old style, with tiny figures in a panoramic space. The New Testament subjects set in contemporary Flanders are particularly important: *The Massacre of the Innocents* (Plate 34), *The Numbering at Bethlehem* (1566. Brussels, Musées Royaux des Beaux-Arts), and *The Adoration of the Kings* (1567. Winterthur, Reinhart Collection).

Bruegel's contemporary reputation and presumably much of his income depended on the designs that he made for professionally engraved and widely circulated prints of landscapes and various themes of a religious or allegorical nature. His paintings cover the same range of subjects and are conceived according to the same principles of design; in both media, the wide panoramic composition and high viewpoint are adopted. Bruegel's work is steeped in popular imagery and popular thought in a way that is without parallel in the art of either Van Eyck or Rubens. If a detail in a Bruegel design is difficult, or impossible, to explain (and many are: the literature on him is often very learned), this is not because the artist was appealing to the erudition of his public but because the image represents an idea, a proverb or even a turn of phrase that—like many a reference in Shakespeare, or in old ballads—has long since passed out of common usage.

The principal standards by which Bruegel's contemporaries judged his work were diversity of incident and accuracy of detail; and Carel van Mander rightly claimed that Bruegel excelled in both. The variety of incident is self-evident, although sixteenth-century values need to be taken into account if it is to be fully savoured. In an age when books, like education, were scarce and when there were no equivalents to the modern media of cinema, television and newspapers, paintings and prints had to satisfy, to a greater degree, that craving for information which is universal and which at root often amounts to no more than a desire to see one's own existence confirmed by the example of others. *The Procession to Calvary* (Plate 13) originally belonged (together with fifteen other Bruegels) to an Antwerp merchant, Niclaes Jonghelinck, and one can imagine him returning time and time again to study its wealth of detail and perhaps even thinking, as he studied the lower left area of the painting, that he had never before seen so convincing a portrayal of a man running. This passion for facts was by no means confined to paintings and engravings; it was part of the spirit of the age, and found an eloquent expression in the cabinets of curiosities that were a pride of ruling families, and in the activities of Bruegel's friends, such as Ortelius, one of the greatest geographers of his time who, in the very same year as *The Procession to Calvary* was painted, completed a *mappemonde*; and Plantin, the Antwerp printer who during the same period was planning the *Biblia polyglotta*, designed to fix the original text of the

Old and New Testaments on a scientific basis. The same spirit permeates Bruegel's *Children's Games* (Plate 3), which now seems among his least attractive pictures precisely because the demands of a 'catalogue' have been allowed to override more pressing formal considerations.

There was an equally ready market for pictures and prints that stressed the diversity of nature and foreign lands, about which people might have heard but had little chance of seeing for themselves. In a world where travel was slow, dangerous, uncomfortable and extremely expensive, the traveller's tale was something to conjure with: and as he gazed at Bruegel's great winter landscape (Plate 35), as his eyes followed the hunters over the crest of the snow-covered hill, across the lakes dotted with skaters, past the slow, creaking cart and on through the village, over the hump-backed bridge and through the fields to the ice-locked sea, it is difficult to believe that even the most sophisticated visitor, at Niclaes Jonghelinck's house, did not enjoy the vicarious sensation of making a journey. How much more readily humbler purchasers of the prints must have succumbed to the spell as they examined, inch by inch, Bruegel's world in miniature. 'Nothing more in Art or Nature', we find Edward Norgate writing early in the seventeenth century, 'affords soe great variety and beauty as beholding the farre distant Mountains and strange situation of ancient Castles mounted on almost inaccessible Rocks'—a remark that might well have been inspired by one of Bruegel's own prints or knowledge of a painting such as *The Gloomy Day* (Plate 22 and detail on Plate 31).

These landscapes must often have been collected as we accumulate picture postcards today, and were judged less as 'works of art' than as evidence of the abundance and variety of the natural world. The spirit in which they were brought together is perhaps suggested by a small, early seventeenth-century panelled room in Rosenborg Castle, Christian IV's summer residence in Copenhagen. Let into the panelling, in three rows, one above the other, are a whole series of small late sixteenth- and early seventeenth-century Dutch and Flemish pictures that include an early copy of Bruegel's *Winter Landscape with Skaters and a Bird-trap* (1565. Delporte collection, Brussels).

But this richness of incident in Bruegel's work is not only an historical phenomenon that has lost its power to move us. It is an abiding source of pleasure. Quite apart from their other qualities, Bruegel's paintings and prints are extremely entertaining. They are fun to look at.

The accuracy of Bruegel's rendering of detail may also seem self-evident; but it is perhaps in greater need of comment in the light of contemporary art than the wealth of incident in his work.

Although Bruegel became a supreme master of figure painting and landscape, it was as a delineator of the natural scene that he began his career. The landscape paintings most admired in the Netherlands during the 1540s, when Bruegel was growing up and when he would have been particularly receptive to external impressions, were of a fantastic kind, in a style developed primarily by Joachim Patenier (active 1515; died not later than 1524). Its chief characteristics are a high viewpoint; great areas of land and sea depicted with microscopic precision; and an implicit appeal to the spectator to believe that he has been taken up into a high place to be shown the kingdoms of the earth.

Bruegel adopted the compositional methods of Patenier and his followers, very directly but still somewhat tentatively in such early paintings as the 1553 *Landscape with Christ appearing to the Apostles at the Sea of Tiberias* (Private Collection), and with increasing assurance in the 1560s, when he applied the system of a high viewpoint, with space sweeping away to a distant horizon, in figure subjects (Plates 6, 12, 13, 34, 36, 46) as well as in the great landscapes (Plates 22, 24, 35). Patenier's 'world landscapes', as they have been aptly called, are certainly charming; but it must be admitted that they lack any high degree of visual conviction. The vision has clear epic implications but dwindles, for lack of convincing factual support, into a toy-scape. Bruegel, on the other hand, makes the system work, absolutely, by virtue of the quality and conviction of his detail.

At the same time, the seeming accuracy of the parts in Bruegel's work should not blind one to the artifice of the whole. *The Hunters in the Snow* (Plate 35) might well be taken for a view of Flanders in the grip of winter. This is not the case. The flat fields and small hamlets in the middle of the picture, proper to the Netherlands, are combined with the snow-covered mountains of Switzerland that Bruegel had drawn in the early 1550s. *The Hunters in the Snow, The Gloomy Day* (Plate 22) or *The Return of the Herd* (Plate 24) are as much made up of improbably reconciled parts as any scene by Patenier, Jan Matsys, Herri met de Bles or other sixteenth-century landscape specialists. Even the high viewpoint with figures in the foreground disappearing over the brow of a hill is a Mannerist pictorial convention of the time and can be traced back, through Netherlandish paintings such as Jan van Scorel's *Christ's Entry into Jerusalem* (Utrecht, Centraal Museum), to *The Story of the Flood* on the Sistine Ceiling.

It does not take very long to realize that there is a central contradiction in Bruegel's art, a dichotomy between the artificial, conceptual approach to the design as a whole and the naturalistic treatment of the details. These two modes of seeing are implicit in his drawings, which, apart from the finished, preparatory studies for prints, fall into two distinct groups: the landscapes seen from a distance, and the sketches of peasants observed close to and often inscribed *naer het leven* (from the life) with the same pride as Van Eyck painted the words *Johannes de eyck fuit hic* (Jan van Eyck was here) on the wall in the portrait of the Arnolfinis.

But contradictions, with great artists, do not weaken their art; they become points of tension that generate power. The wide framework and the suggestion that we are looking at an entire world give Bruegel's figures and groups a precise and essential part of their visual eloquence. 'Everyman' is more touching when he can be seen to act out his life in a context. The very scope and breadth of the vision also has a resonance of its own: the windy spaces in that harsh paradigm of winter, *The Gloomy Day* (Plate 22), affect the senses like some great Shakespearean image:

And blown with restless violence round about

The pendent world.

However, the people, groups and incidents observed *naer het leven* give these epic compositions their humanity and conviction. The small scale of the figures establishes, by contrast with the space they inhabit, the frailty of the human species, and it is this suggestion of frailty which counteracts the brutishness and pessimism of Bruegel's point of view and is partly what makes these great paintings so pro-

foundly moving. They would not be so moving, however, if they were not so well observed. Bruegel's powers of delineation—his ability to draw ordinary people as they are, to pin down, with economy and ease, exactly how they stand and walk and gesticulate—were masterly, and impart an almost documentary character to scenes like *The Fight between Carnival and Lent* (Plate 2).

Pieter Bruegel had a literal mind. And it was this literalness, a tendency to see a great many trees, each clearly defined and separate, before he saw the wood, that enabled him—quite unconsciously—to avoid the pretentious, rhetorical elements implicit in the Mannerist compositional schemes that he adopted. It was also this literal cast of mind, combined with his rare capacity for visual invention (in a reincarnation, Bruegel might well have been a great comedian in silent films), which made his designs so well suited to reproduction as popular prints.

Commissioned to revive the Bosch idiom, it is hardly surprising to find that Bruegel borrowed and adapted a number of its most prominent features. The most important, a development of the way in which he was already organizing his landscapes, was the idea that a given theme was precisely that, a theme on which an infinite number of variations could be played, each episode, each group of figures being set down, side by side, on a receding stage. This method of composition, apparent in such typical Bosch designs as *The Garden of Delights* and *The Hay Wain* (both the original paintings are now in the Prado, Madrid), Bruegel used at first with little finesse. In the *Children's Games* (Plate 3) the perspective is too rigid and the disposition of the groups monotonous. By degrees, however, he learned how to set down his figures more naturally in space less rudely constructed. In *The Triumph of Death* (Plate 6) the composition is organized round a diagonal which runs from top left to bottom right, on the same principle as the *Children's Games*; but how much more subtle the arrangement has become. Instead of draining the scene of life, as it does in the earlier picture, the strong diagonal now gives an underlying visual support to the great quantity of details in which the painting abounds.

Bruegel also learned from Bosch how to achieve disturbing and often horrific effects by increasing the scale of certain key figures in a design—such as 'Mad Meg' and the Tempter, with the symbolic ship on his back, in *'Dulle Griet'* (Plate 4)—as well as a method of creating fiendish monsters by combining features from different animals, birds and reptiles in one alarming body. *The Fall of the Rebel Angels* (1562. Brussels, Musées Royaux des Beaux-Arts), one of Bruegel's last paintings in this genre, is a particularly brilliant example. After this date he preferred to use more straightforward imagery.

Bruegel's literalness of mind also helps to explain the extraordinary degree to which his works—especially the paintings—have retained their aesthetic vitality and moral force. Little is known about Bruegel himself, but it is hard to imagine that he was an 'intellectual' artist, constantly examining his own intentions and over-aware of what he might do, of what he could do or of what he was expected to do. The paintings, drawings and prints never convey an impression of executive energies dissipated through mental speculation, as is the case with Leonardo da Vinci. Bruegel worked in a practical fashion, completing his pictures, as he completed many of his drawings, down to the last stroke. He was not in the habit of

concentrating his efforts on the most important figures in a composition, so that in all his paintings are to be found the most exquisitely realized details, just as in Shakespeare superb lines are given to quite minor characters. On the extreme left of *The Procession to Calvary* (Plate 13), for example, there is a man with a heavy basket on his arm passing two women, one of whom carries a large pitcher on her head. The group is not important, it is tucked away at the side, and yet those figures, so vivid and rich in life, are drawn with a steely precision and economy of which Degas would have been proud. It is impossible to study Bruegel's paintings for long and not be moved by the sheer generosity of his talent.

The way in which Bruegel approaches a theme can be equally literal. Raphael's famous interpretation of *Christ on the Way to Calvary* (Madrid, Prado) has a small number of timeless, idealized figures, conceived on a large scale and shown in close-up. There could hardly be a greater contrast than Bruegel's panel in Vienna (Plates 13, 14, 16, 19, 20). Christ here is all but lost amid the crowds which stream up the hill to watch the death of the Saviour just as if they were on their way to a contemporary execution. It is precisely this elimination of the traditional weight of significance which helps to create a new depth of feeling. Bruegel goes even further than that. In the lower left area of the picture, Simon of Cyrene is being coerced by the soldiers into helping Christ carry His Cross. He does not want to perform this simple act of mercy, and is supported by his wife, who tries to fend off the troops. And yet, prominent at her waist, there is a rosary. That this scathing visual comment on hypocritical Christianity can be incorporated in a scene illustrating one of the key events on which Christianity itself was based reveals both the pessimism and the independence of Bruegel's point of view. No church would have sanctioned such a detail in an altar-piece. And the manner in which it is done shows Bruegel's subtlety as an artist, evident in the way he has taken advantage of his own naturalistic, anachronistic style. Had he used an idealizing classical idiom and Roman draperies, consonant with the Ancient World, it would have been impossible to make the point.

It is the un-nerving freshness of Bruegel's response to scriptural and allegorical subjects that gives his interpretations their core of harsh, even sometimes cruel, vitality. In Christian art, the death of the Virgin Mary often becomes a comforting and upholstered piece of hagiography. Bruegel's version (Plate 30), painted about 1564 for his friend, Ortelius, is anything but that. The vision granted to St John the Evangelist, seated in a semi-trance in the lower left corner of the picture, is of a frail and seemingly timid old woman in an enormous bed, surrounded by spectral figures whose attitudes of reverence are not without hints of almost menacing fanaticism, and whose movements are more reminiscent of mice or bats hypnotized by the light than of the patriarchs, martyrs, confessors and holy virgins who according to the *Golden Legend*, which Bruegel followed, were present at the Virgin's death. But such is the strangeness and intensity of his imagination, and so magnificently painted is this small panel, that it conveys a greater sense of religious mystery, of an absolutely unique event, than any number of bland, conventionally correct images.

The theme of earthly vanity also gains immeasurably from being treated in this literal way. In *The Triumph of Death* (Plate 6), there is no element of Miltonic

grandeur to soften, through its very resonance, the horror and despair: instead, an organized, mechanized army going about its professional business. Bruegel retains the painful simplicity, the disconcerting ordinariness of an attitude to death particularly prevalent in the mediaeval world. Anyone who has stood in front of Francesco Traini's mid-fourteenth-century fresco of *The Triumph of Death* in the Camposanto at Pisa will immediately recognize the kinship with Bruegel's painting. Sion Cent, the Welsh author of an early fifteenth-century ballad, *The Vanity of the World*, captures the spirit perfectly in his stumpy couplets:

Futile the frantic plotting

Of weak clay, dead in a day.

The pessimism is absolute. Bruegel strips away the last shreds of illusion about human destiny, which neither rank, faith, love nor money can reverse, and he even adds to the note of terror with touches of bitter and ironic visual humour. In the extreme bottom right-hand corner of the picture the duetting, amorous couple has unwittingly become a trio, with death playing a fiddle. This is one of the sharpest, as well as one of the best, visual jokes in European art, and is on a level with Hogarth and Goya at their finest.

The figure compositions that Bruegel designed for Cock were almost always of a satirical, moralizing kind, and this is the mood that characterizes most of his paintings as well. The question of form and content in Bruegel's work, the extent to which he was expressing his own feelings, and the degree to which he was exploring the obvious implications of the commission, is very complex and does not lend itself to any easy, clear-cut explanation.

Pending the discovery of factual evidence, all that may be done with any degree of safety is to stress the pessimism of Bruegel's outlook. The choice of theme and the treatment invariably imply a very poor view of humanity, which is variously regarded as greedy and fatuously optimistic (e.g. the print of *The Alchemist* or the painting in Munich of *The Land of Cockaigne*), arrogant (*The Tower of Babel*, Plate 12) and blind to true values (*The Parable of the Blind*, Plate 45, or *The Procession to Calvary*, Plate 13)—and often hypocritical into the bargain. The ways in which people chase after pleasure are seen to be as pointless as they are disgusting since all ends in death (the print of *Big Fish eat Little Fish* or *The Triumph of Death*, Plate 6). The frailty of the human species is at all times contrasted with nature, which follows its seasonal course sublimely indifferent to man's puny activities.

In trying to assess the temper of Bruegel's work, however, it is also as well to bear in mind that he lived in a period of acute political and religious strife. The Netherlands were under Spanish rule and when, in 1555, Charles V abdicated in favour of his son, Philip II of Spain, the Inquisition became more stringent than it had previously been. The combination of political and religious persecution inevitably led to revolutionary outbreaks, notably those of 1567 under William of Orange. Reprisals were swift. The infamous Duke of Alba, appointed governor-general of the Netherlands in the same year, set up a notorious tribunal known as the Council of Troubles. *The Massacre of the Innocents* (Plate 34)—where the Biblical story is set in a sixteenth-century Flemish village, which is being sacked—was probably not painted with a direct political implication in mind, but there can still be little

doubt that for Bruegel's contemporaries the image would have had emotive overtones that are lost to us today. It is against this tragic background that his work must be viewed. It was a terrifying time, when those who looked for guidance to the pole star of religion would too often have seen a luminary suffused with blood. An inventive imagination, underlying realism, the capacity to record traits of behaviour accurately, a deeply pessimistic concern with the human condition— these are all important elements in Bruegel's art. And the proportions in which they appear and the skill with which they are combined help to account for its power. But these factors alone cannot explain the greatness of Bruegel's work. Seventeenth-century genre painting, after all, and eighteenth-century conversation pieces, not to mention the crowded Victorian beaches and railway stations of an artist like Frith, are all filled with realistic detail. Often a great deal of didactic information about life is presented. Yet pictures of this kind invariably lack the touch of life. What sets Bruegel apart from Frith is what differentiates a statue from a waxwork: the waxwork may be more detailed but it is not created in the light of any compelling or overriding aesthetic point of view.

It was this aesthetic awareness, this deep commitment to the intrinsic properties of colour and line, that saved Bruegel from the twin pitfalls of triviality and mere literary illustration. His appetite for detail was certainly as acute as that of any sixteenth-century Netherlandish artist. What sets him apart, and generates a constant source of visual tension and vitality, is that this additive instinct was balanced by an equally strong feeling for simplification. Approach any of Bruegel's paintings closely and what is usually meant by the term 'detail' is often hard to find. Eyes are reduced to round holes, heads resemble footballs, bodies punched sacks of flour, while clothing is nearly always generalized. This is particularly clear in the drawing of the figures and animals in *The Return of the Herd* (Plate 24). Even the paint itself is often applied sparingly—the Virgin's robe in *The Adoration of the Magi* (Plate 21) is a revealing instance.

This refusal to stress detail and texture helped Bruegel to give the maximum emphasis to the silhouette of his forms; it was on the silhouette that he relied for many of his most telling effects. Training and association with Hieronymus Cock may perhaps explain this preference. As in the case of Daumier, Bruegel's experiences as a print-designer, working in black and white without the possibility of colour, must have increased his capacity to think if not exclusively, at least primarily, in terms of line and outline. And certainly what is memorable about Bruegel's figures and groups are not the faces or the buttons and hair but overall shapes, the flat pattern formed by the outlines of the figure. *The Hunters in the Snow* (Plate 35) has achieved enormous popularity largely for this very reason: the visual impact of the striding figures, the dogs and the receding tree-trunks is as instantaneous and clear-cut as in a poster by Toulouse-Lautrec. The horseman in yellow on the extreme right of *The Conversion of St Paul* (Plate 36), also has a rich heraldic simplicity that had hardly been seen in European art since Uccello. Like Degas, Bruegel was evidently fond of figure-shapes that are formally complete in themselves; both loved the visually self-contained form; and it is noticeable how often Bruegel chooses to show his figures from the back, which presents a much more simplified shape.

It is this sense of shape, this ability to find for every idea, every observed fragment of the natural scene, both animate and inanimate, a striking and memorable pictorial equivalent, that is the crown of Bruegel's achievement as an artist. Everywhere you look in his paintings, drawings and prints you will find his acute sensitivity at work, breathing visual life into a looped-up curtain (Plate 30), the roofs of the town nestling round the base of *The Tower of Babel* (Plate 12), pies on an improvised tray (Plate 40) or the tracery of branches that in *The Gloomy Day* (Plate 22) stands out against the louring sky. Indeed, this feeling for shapes was so strong that it sometimes forced him into a purely two-dimensional emphasis. The surcoat of the kneeling king in *The Adoration of the Magi* (Plate 21) is not painted as if it were being worn, but as if it were lying flat. And in *The Death of the Virgin* (Plate 30), note how the back-rest of the chair is made parallel with the picture surface; it does not project in a way that the perspective of the base would suggest. But had it been drawn 'properly', the chair would have become obtrusive. Like all good artists, Bruegel was absolutely discriminating in his attitude to 'realism'.

Bruegel himself was undoubtedly aware of the emotive power of the silhouette. In several of his most important pictures he used a winter setting (e.g. Plate 34), so that the figures might appear even more striking against the prevailing whiteness of the snow. Concentration on outline had another advantage. It was a useful method of emphasizing an aspect of life in which Bruegel was particularly interested: motion. Bruegel is one of the great delineators of movement in European art, with the result that the world he paints is ceaselessly busy. Since he held a pessimistic view of life, most of the people in his work who are perfectly still invariably turn out to be bloated with food, stupefied with drink, or dead.

It was this simplification of form, rather than its idealized character, which attracted Bruegel to the works of Italian art that he saw and studied, and by which he was influenced after his move to Brussels in 1563. In many of his later paintings (Plates 37, 40, 41, 45, 48a), the figures are large, they quite dominate the scene, but their only real connection with the Italian Renaissance style lies in their massive simplicity. What has changed is not the strategy, but the tactics. To appreciate this fully, it is necessary only to compare *The Parable of the Blind* (Plate 45)—relentlessly pathetic, even harrowing, in its effect—with a Renaissance work that Bruegel may well have known, Raphael's cartoon of *The Blinding of Elymas* (now in the Victoria and Albert Museum, London), which is carried out in an idealizing, classical idiom so strong that even the figure of the false prophet and magician, Elymas, is invested with a tincture of genuine nobility.

Bruegel's world is lavishly filled. But this prodigality is neither heedless nor a sign of weakness. In all his work, with its gaunt mediaeval overtones and suggestion of a magpie's teeming nest, can be traced a purely aesthetic sensibility of the highest order, a knowledge, ruthless in the severity of its application, of what will and will not work *visually*. At the same time, Bruegel is the least self-indulgent of artists: his pictures have a subject, which he respects, and which he does not distort in the interests of virtuosity. Pieter Bruegel cannot be looked upon as a moralist who also happened to paint, any more than he can be regarded as a painter tragically committed to literary illustration. It is precisely from this indivisible unity that both the power and diversity of his art spring. No sooner has the purely visual pleasure

Bruegel's works afford made itself felt, than the very same lines, shapes and colours through which this visual pleasure is conveyed translate themselves into forms of thought, portents, even warnings, that speed to the vaults of the mind, where they linger and echo. Like a hieroglyphic cypher, Bruegel's figures and groups, even whole paintings, have a significant meaning and a telling visual form that coincide exactly. That is why, on entering the room in the Vienna Gallery where so many of his finest works are displayed, the first, overwhelming impression is not of quaintness, nor even of beauty—though the paintings are beautiful enough— but of urgency: extraordinary urgency.

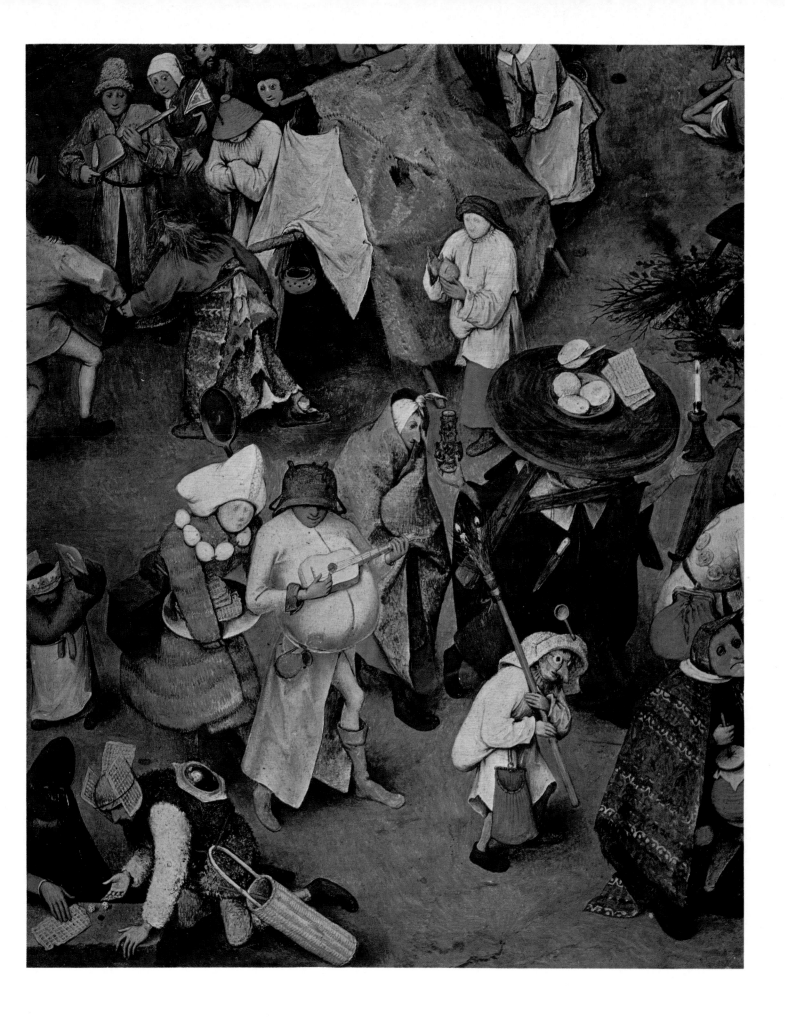

1. Detail from *THE FIGHT BETWEEN CARNIVAL AND LENT* (Plate 2). 1559.
Vienna, Kunsthistorisches Museum

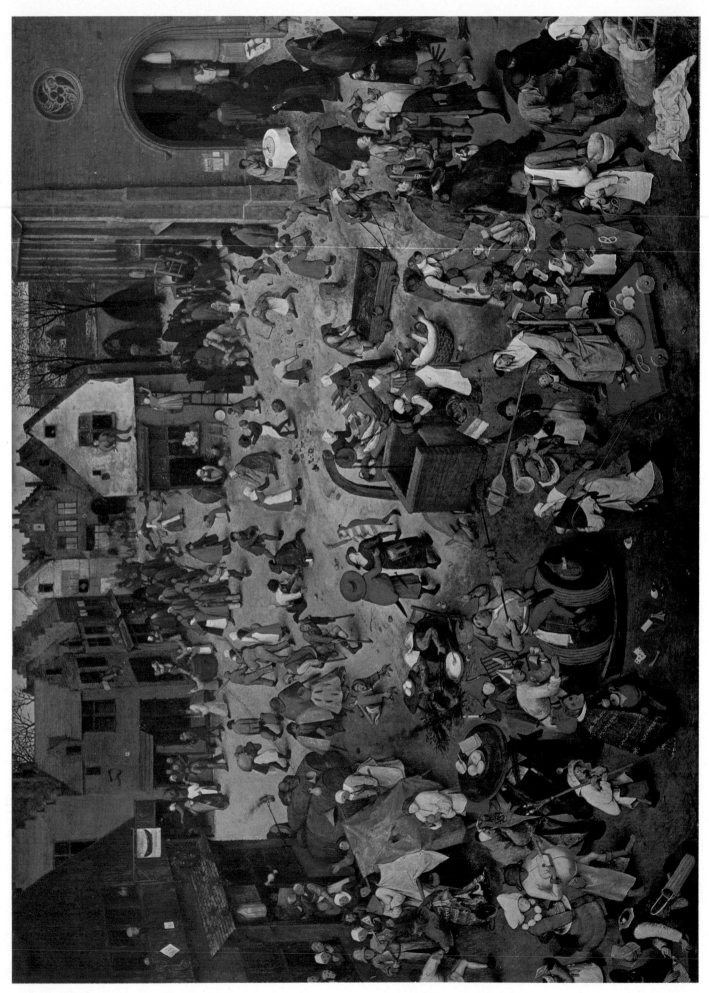

2. *THE FIGHT BETWEEN CARNIVAL AND LENT*. 1559. Panel, 118 × 164.5 cm. Vienna, Kunsthistorisches Museum

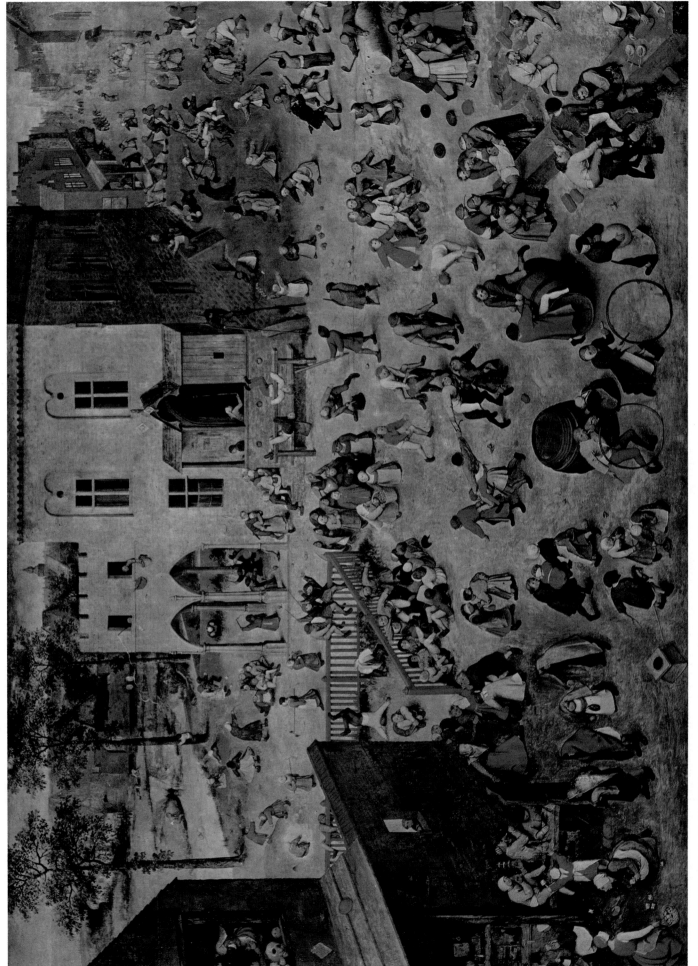

3. *CHILDREN'S GAMES*. 1560. Panel, 118 × 161 cm. Vienna, Kunsthistorisches Museum

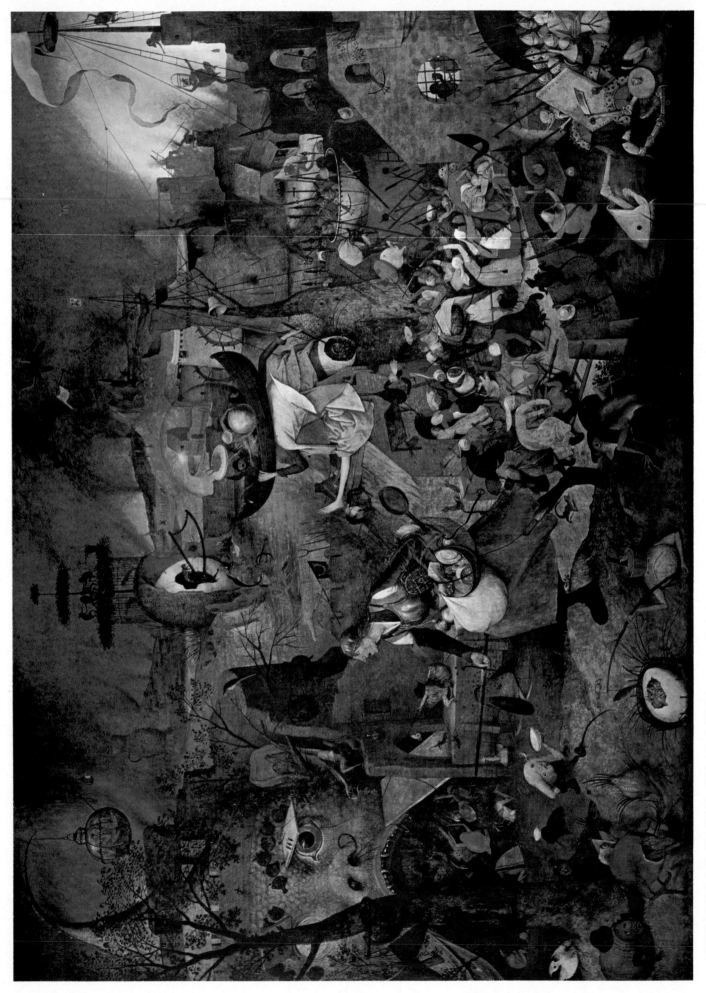

4. *THE 'DULLE GRIET' (MAD MEG)*. 1562. Panel, 115 × 161 cm. Antwerp, Musée Mayer van den Bergh

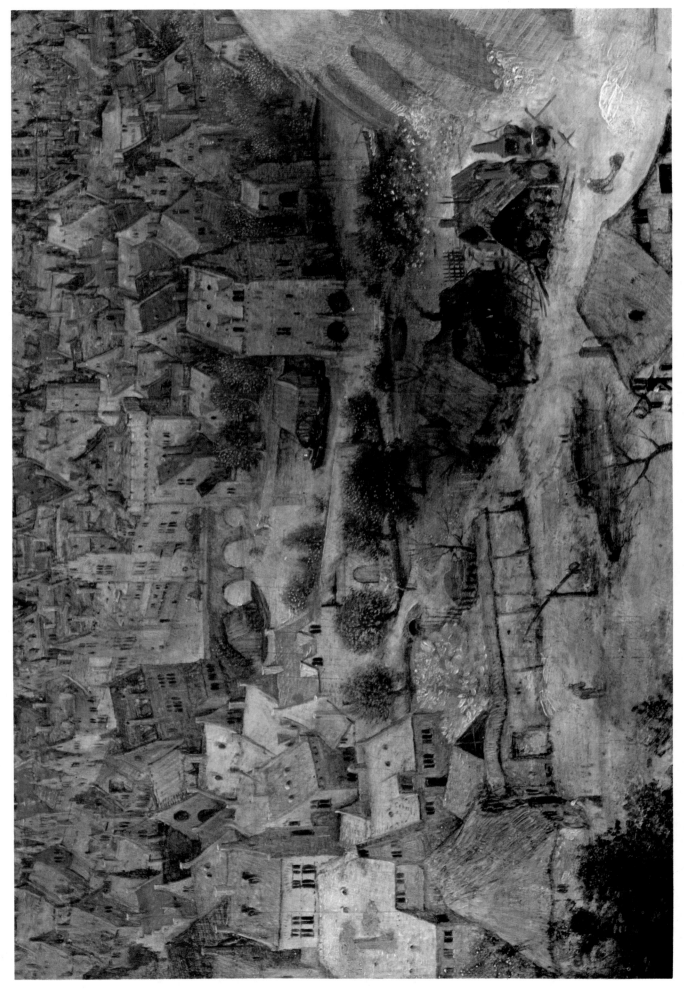

5. Detail from *THE TOWER OF BABEL* (Plate 12). 1563. Vienna, Kunsthistorisches Museum

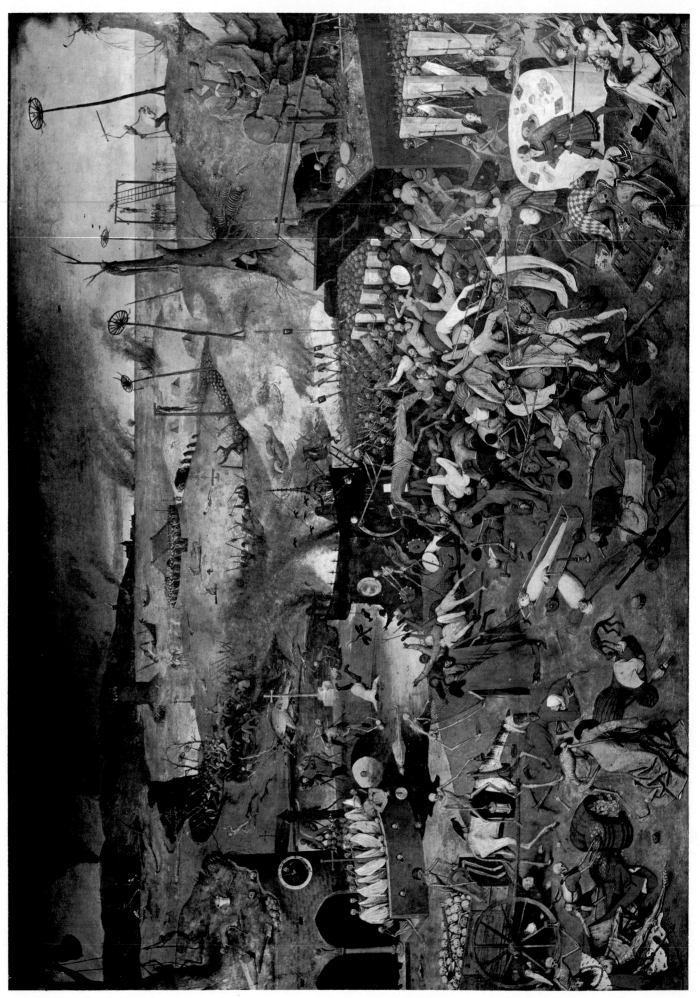

6. *THE TRIUMPH OF DEATH*. About 1562. Panel, 117 × 162 cm. Madrid, Prado

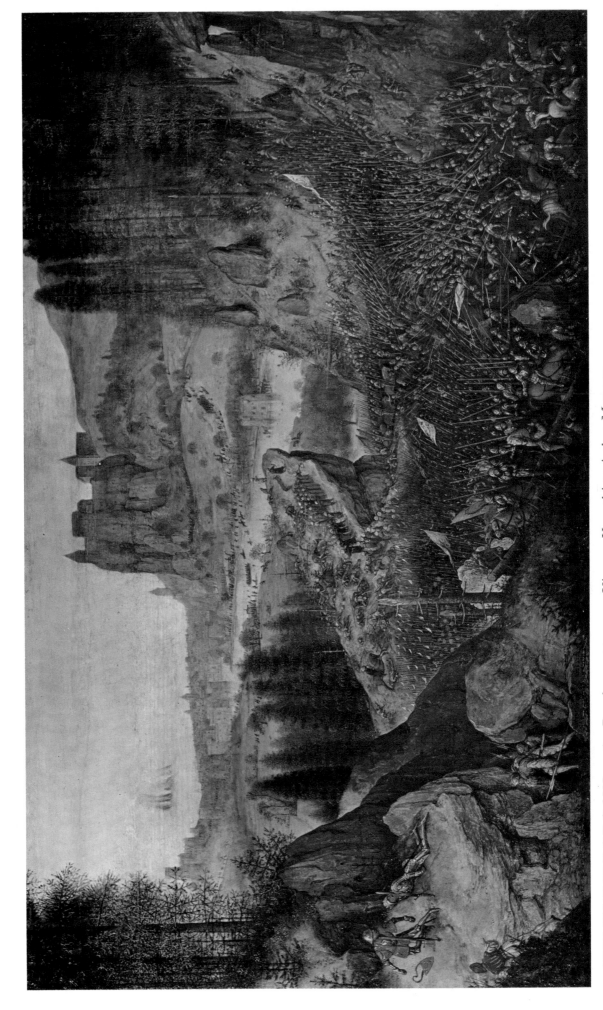

7. *THE SUICIDE OF SAUL*. 1562. Panel, 33.5 × 55 cm. Vienna, Kunsthistorisches Museum

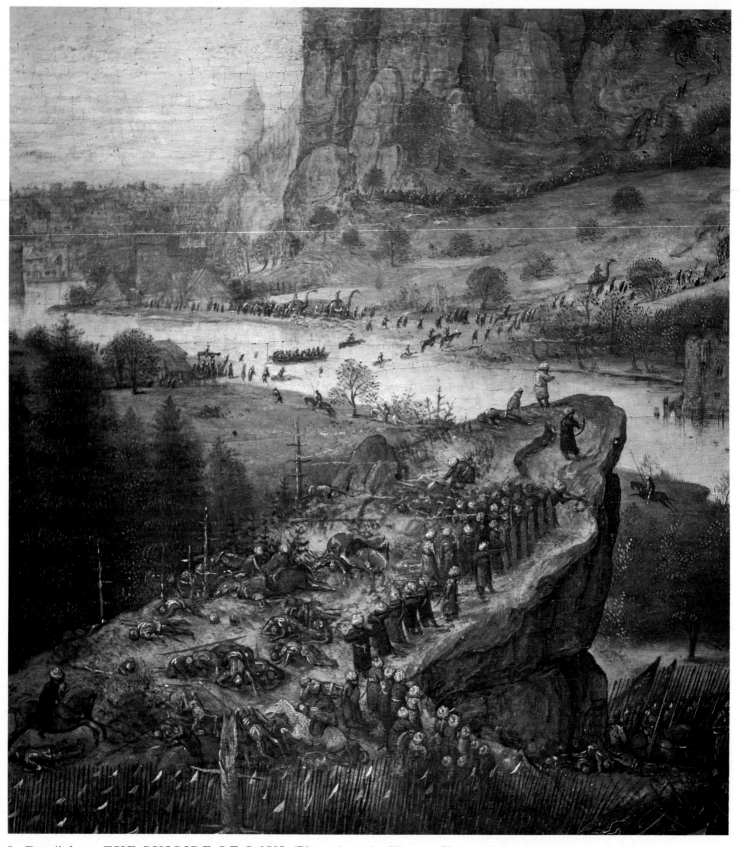

8. Detail from *THE SUICIDE OF SAUL* (Plate 7). 1562. Vienna, Kunsthistorisches Museum

9a. Detail from *THE FIGHT BETWEEN CARNIVAL AND LENT* (Plate 2). 1559.
Vienna, Kunsthistorisches Museum

9b. Detail from *THE 'DULLE GRIET' (MAD MEG)* (Plate 4). 1562.
Antwerp, Musée Mayer van den Bergh

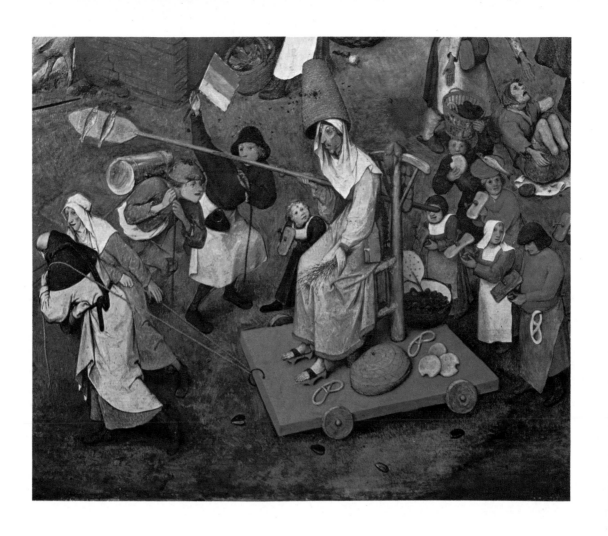

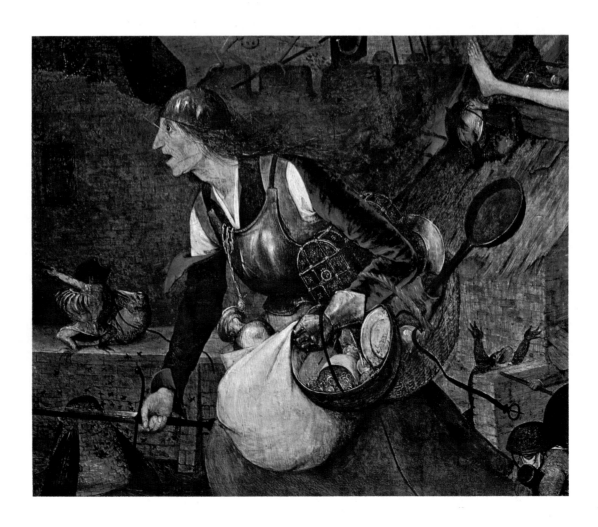

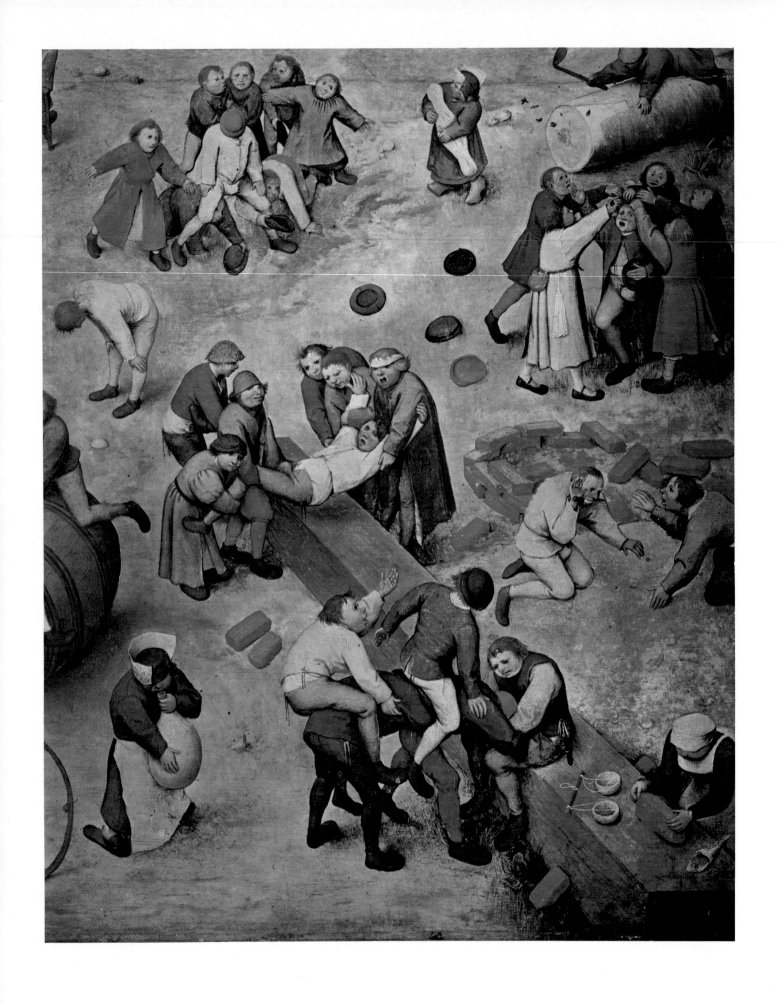

10. Detail from *CHILDREN'S GAMES* (Plate 3). 1560. Vienna, Kunsthistorisches Museum

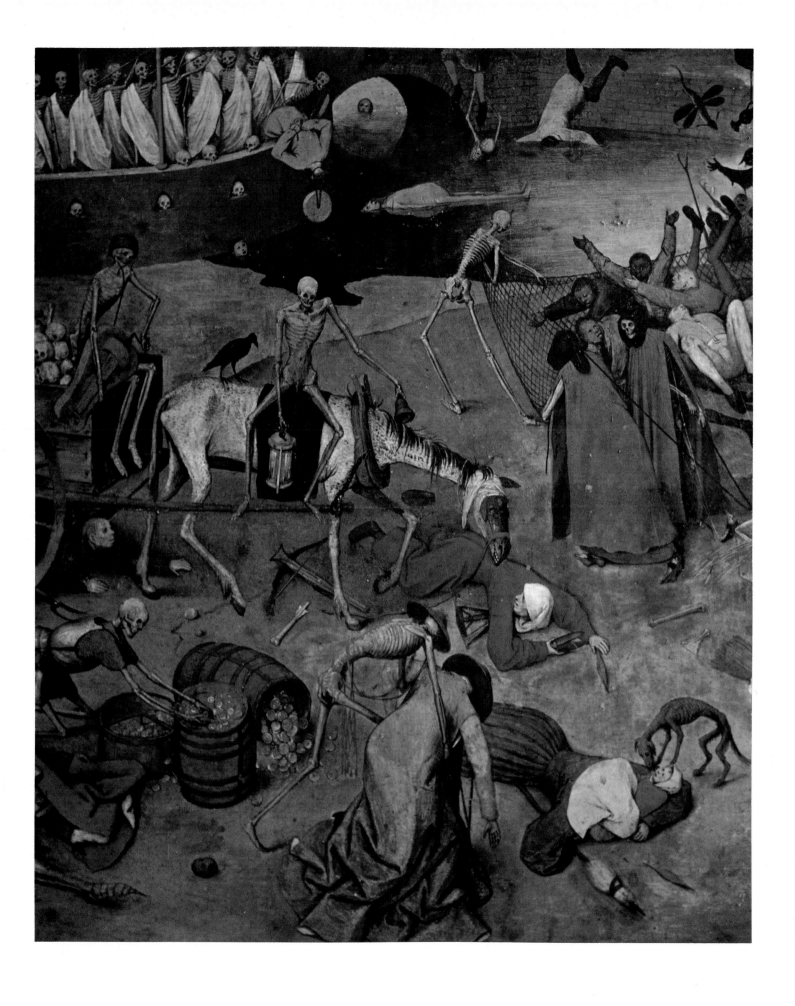

11. Detail from *THE TRIUMPH OF DEATH* (Plate 6). About 1562. Madrid, Prado

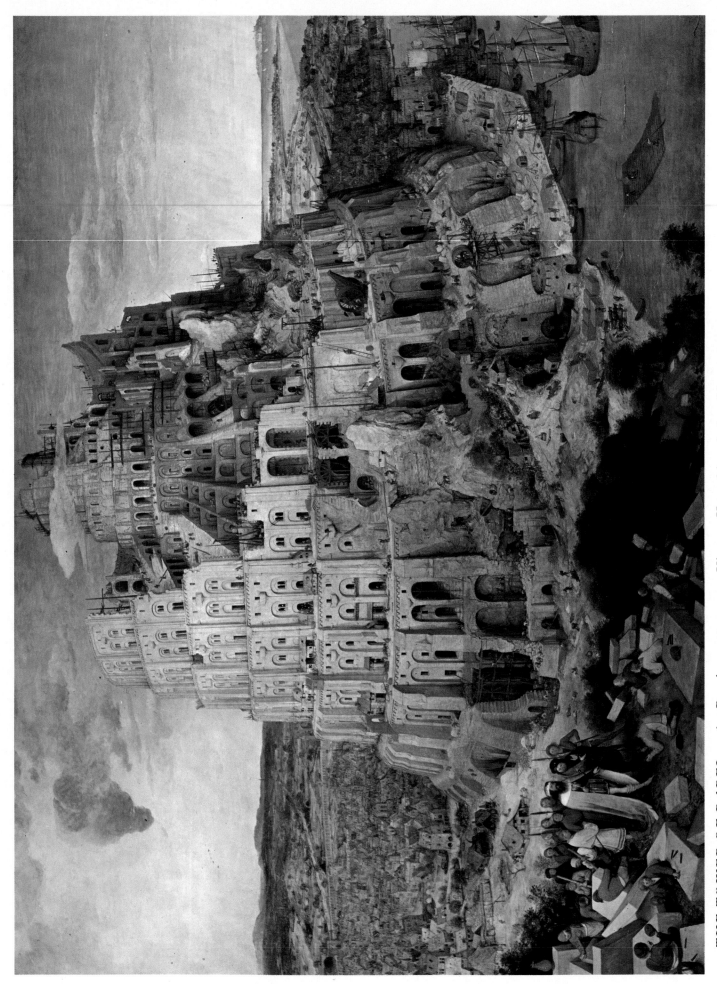

12. *THE TOWER OF BABEL*. 1563. Panel, 114 × 155 cm. Vienna, Kunsthistorisches Museum

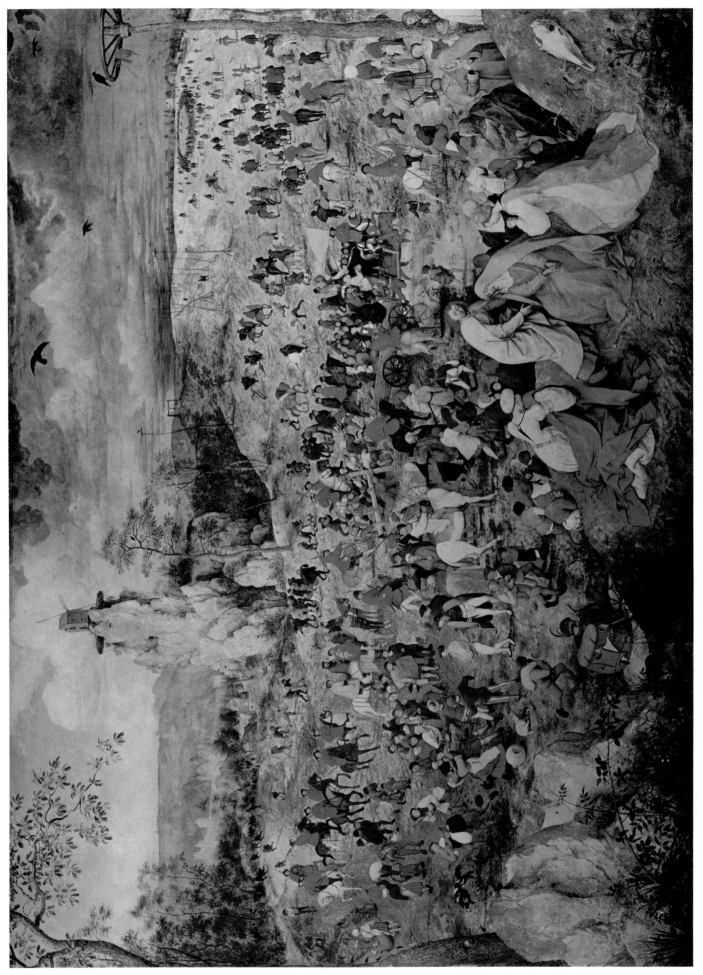

13. *THE PROCESSION TO CALVARY*. 1564. Panel, 124 × 170 cm. Vienna, Kunsthistorisches Museum

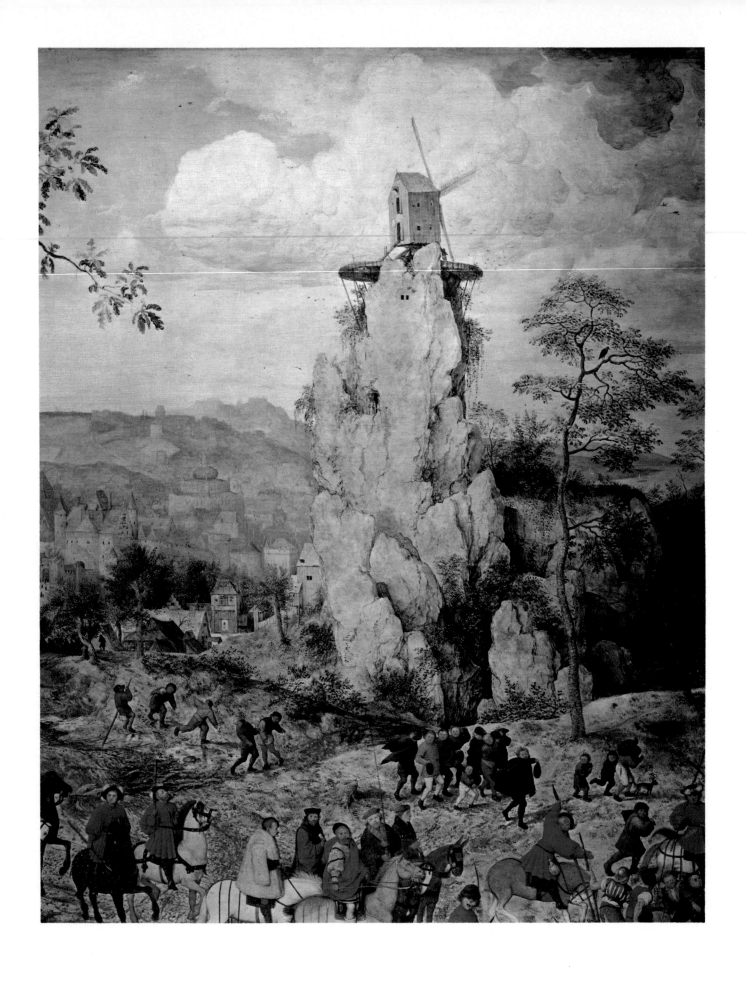

14. Detail from *THE PROCESSION TO CALVARY* (Plate 13). 1564.
Vienna, Kunsthistorisches Museum

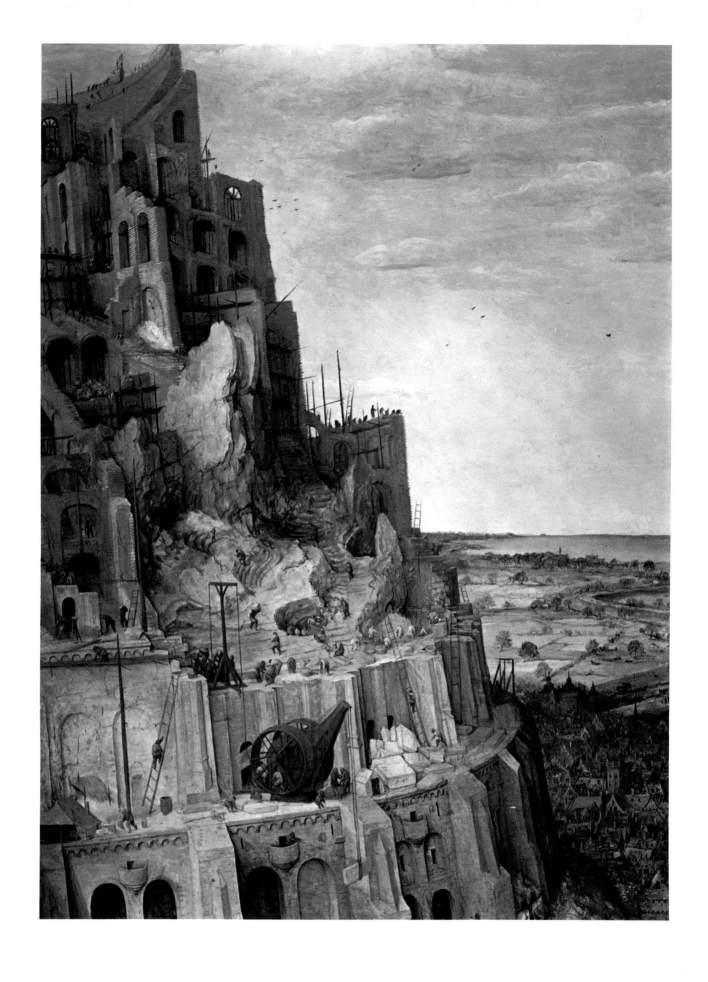

15. Detail from *THE TOWER OF BABEL* (Plate 12). 1563. Vienna, Kunsthistorisches Museum

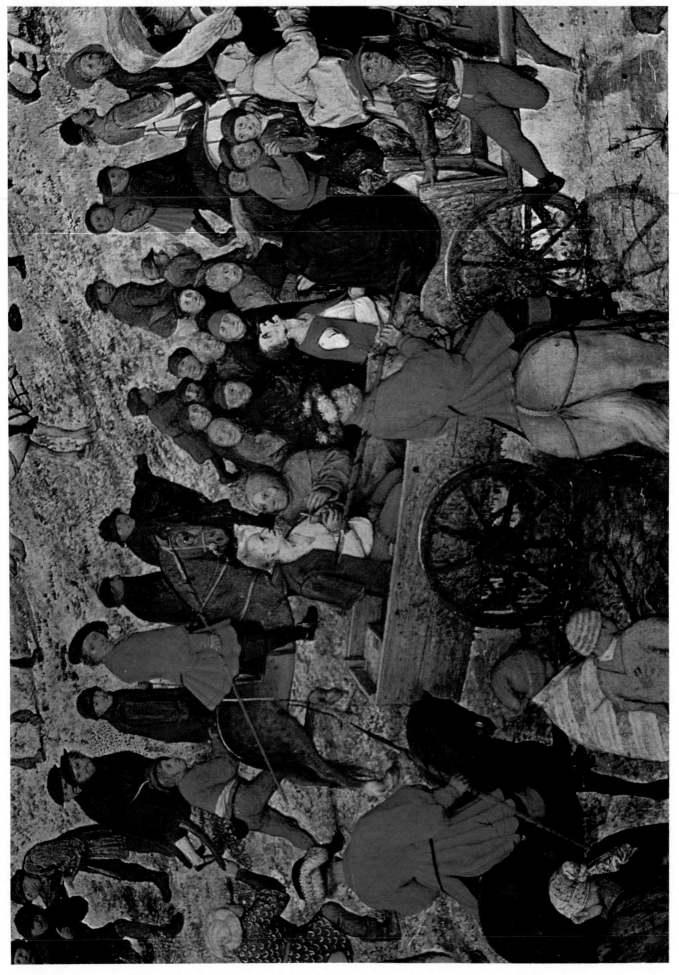

16. Detail from *THE PROCESSION TO CALVARY* (Plate 13). 1564. Vienna, Kunsthistorisches Museum

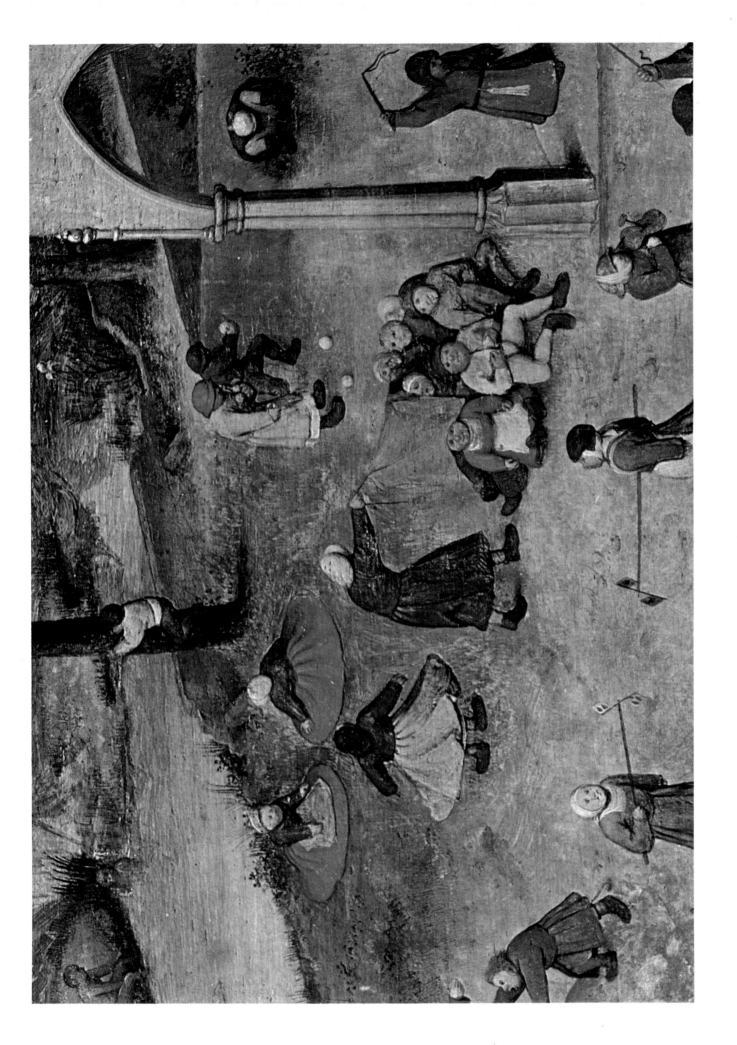

17. Detail from *CHILDREN'S GAMES* (Plate 3). 1560. Vienna, Kunsthistorisches Museum

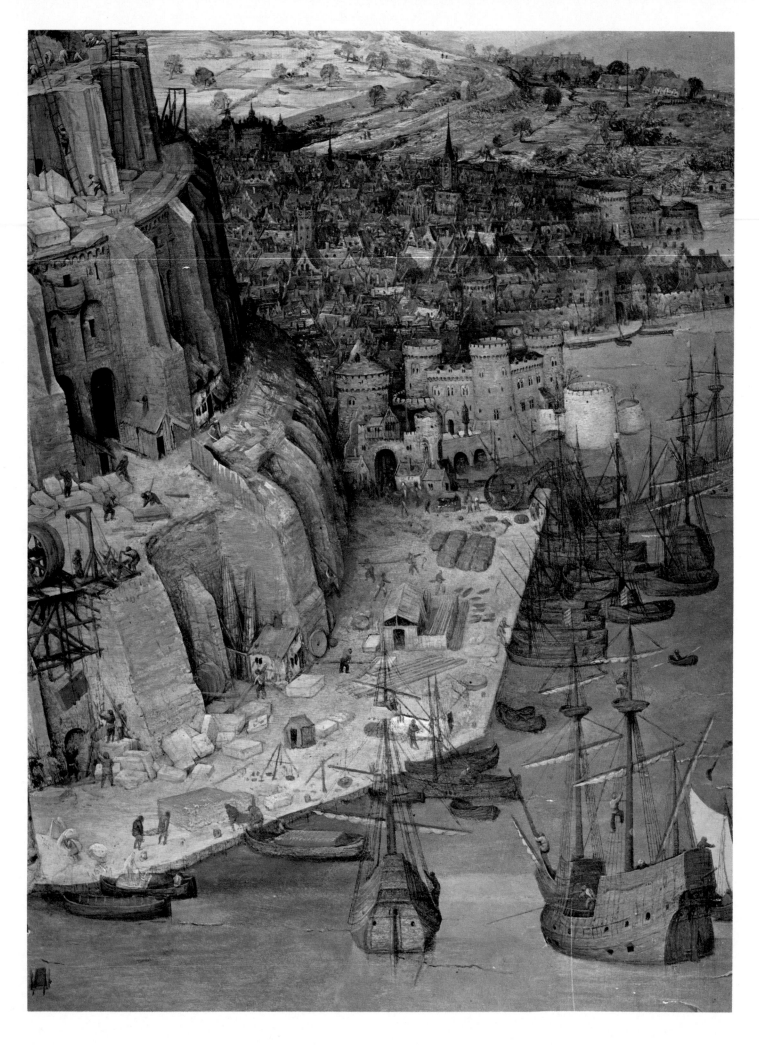

18. Detail from *THE TOWER OF BABEL* (Plate 12). 1563. Vienna, Kunsthistorisches Museum

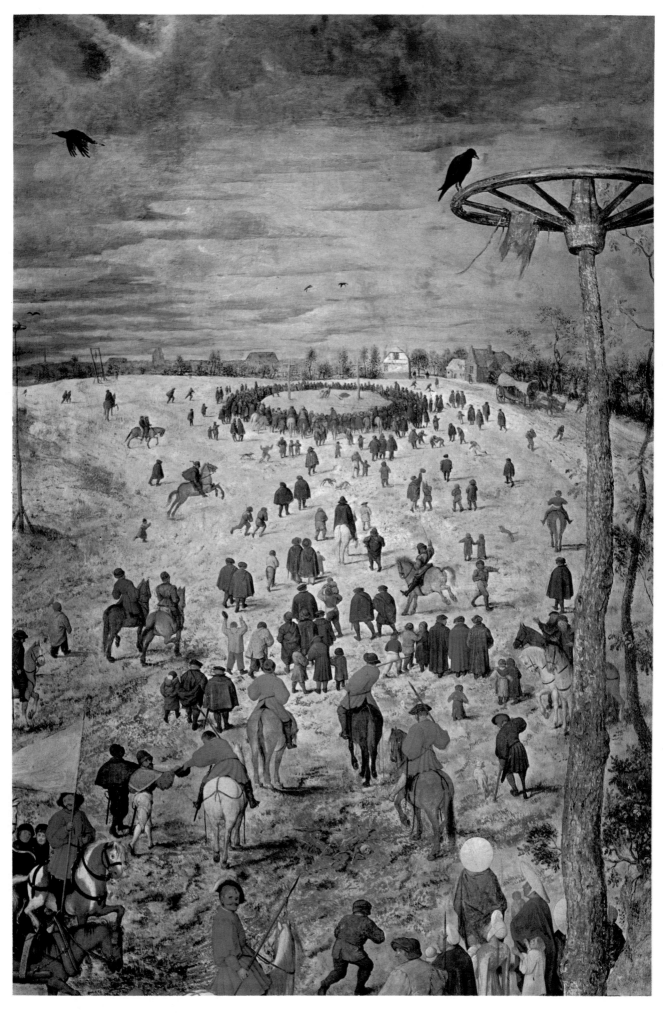

19. Detail from *THE PROCESSION TO CALVARY* (Plate 13). 1564.
Vienna, Kunsthistorisches Museum

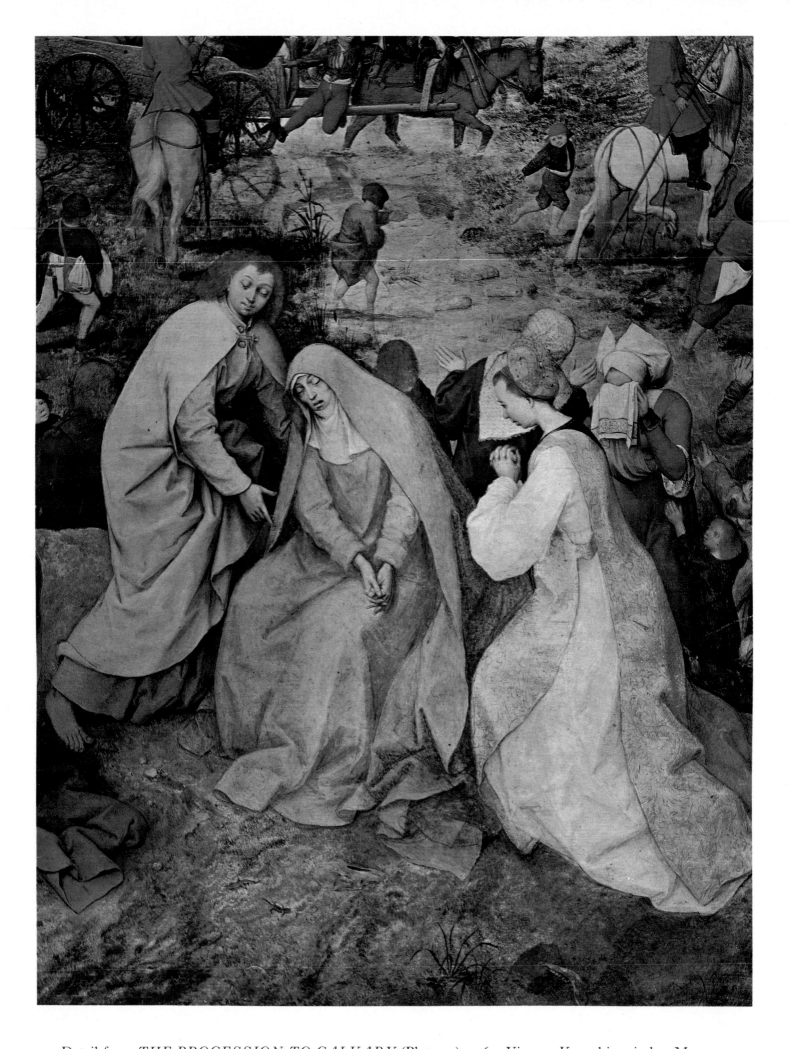

20. Detail from *THE PROCESSION TO CALVARY* (Plate 13). 1564. Vienna, Kunsthistorisches Museum

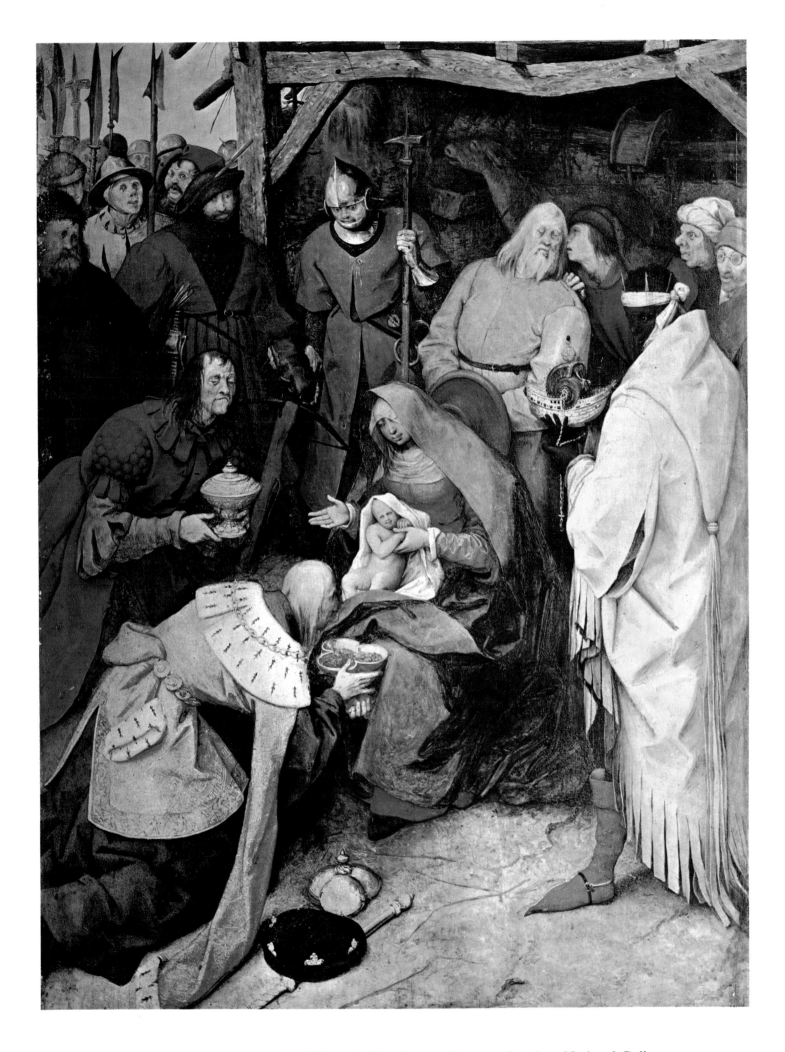

21. *THE ADORATION OF THE MAGI*. 1564. Panel, 111 × 83.5 cm. London, National Gallery

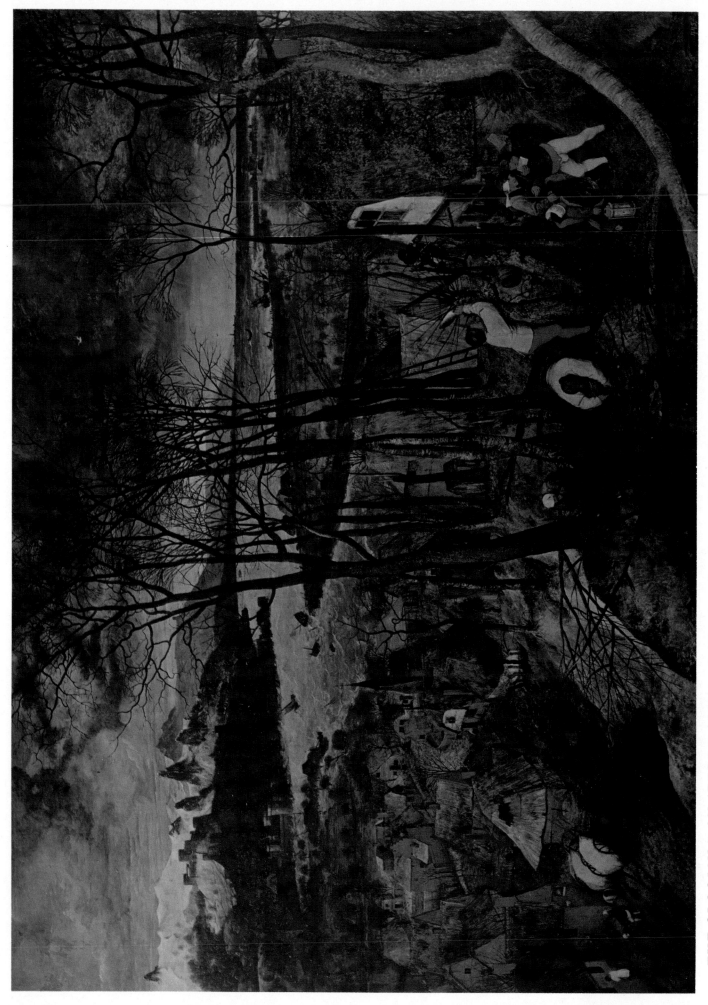

22. *THE GLOOMY DAY (FEBRUARY)*. 1565. Panel, 118 × 163 cm. Vienna, Kunsthistorisches Museum

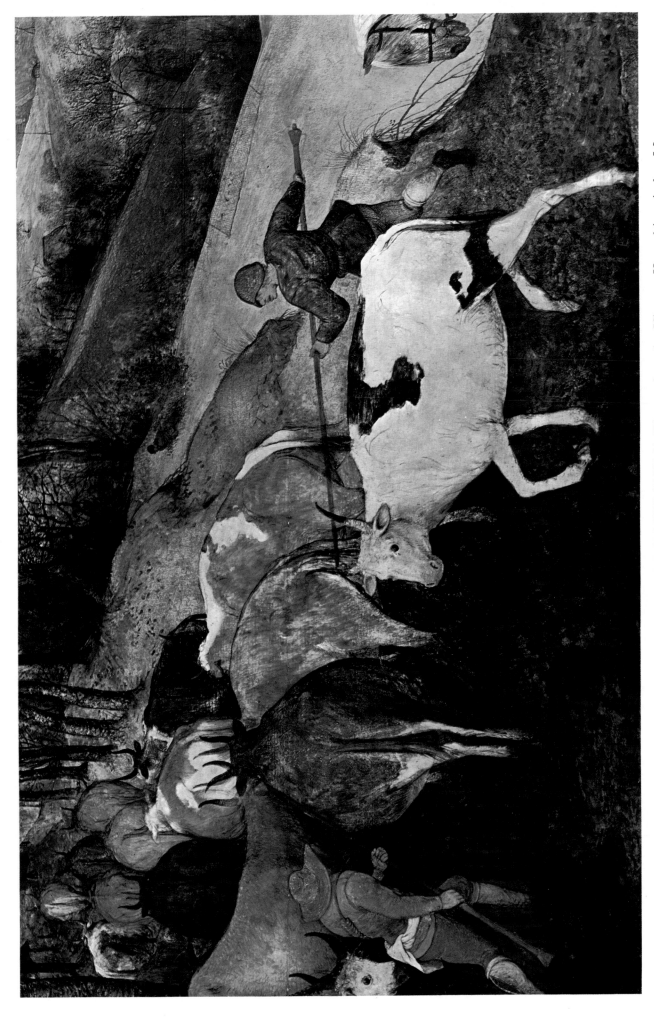

23. Detail from *THE RETURN OF THE HERD (OCTOBER OR NOVEMBER?)* (Plate 24). 1565. Vienna, Kunsthistorisches Museum

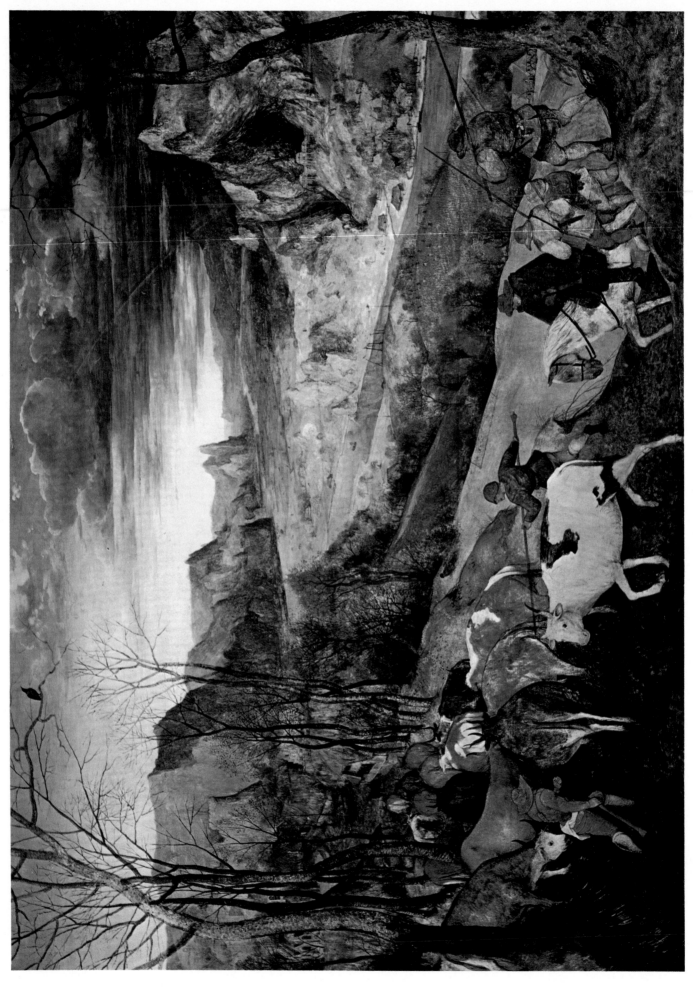

24. *THE RETURN OF THE HERD (OCTOBER OR NOVEMBER?)*. 1565. Panel, 117 × 159 cm. Vienna, Kunsthistorisches Museum

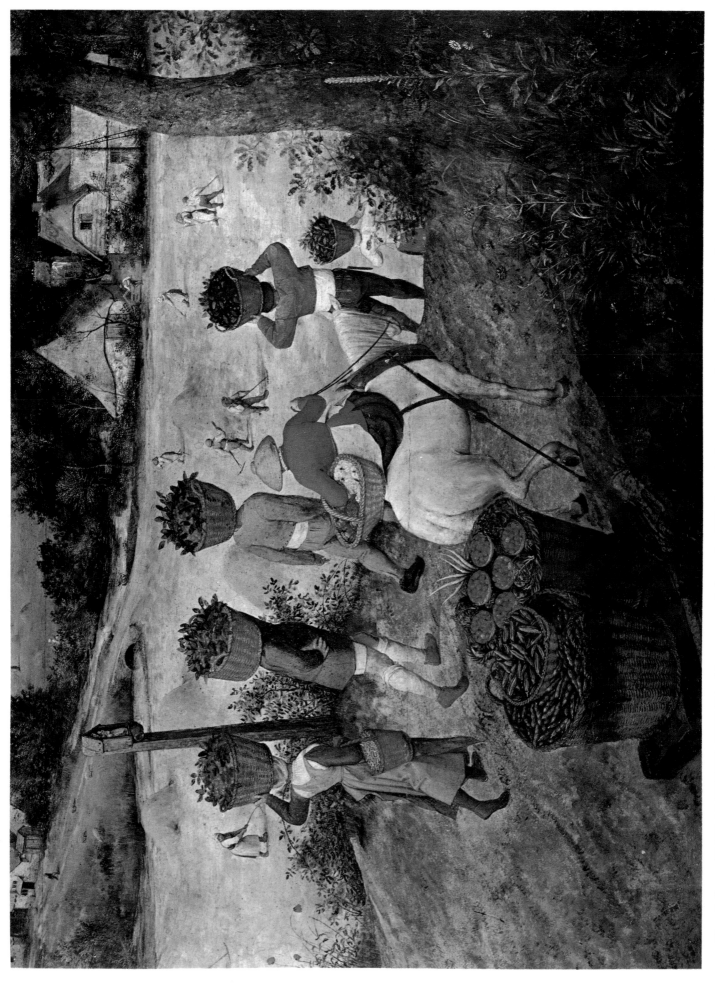

25. Detail from *HAY MAKING (JULY)*. Almost certainly 1565. Whole painting, on panel, 117 × 161 cm. Prague, National Museum

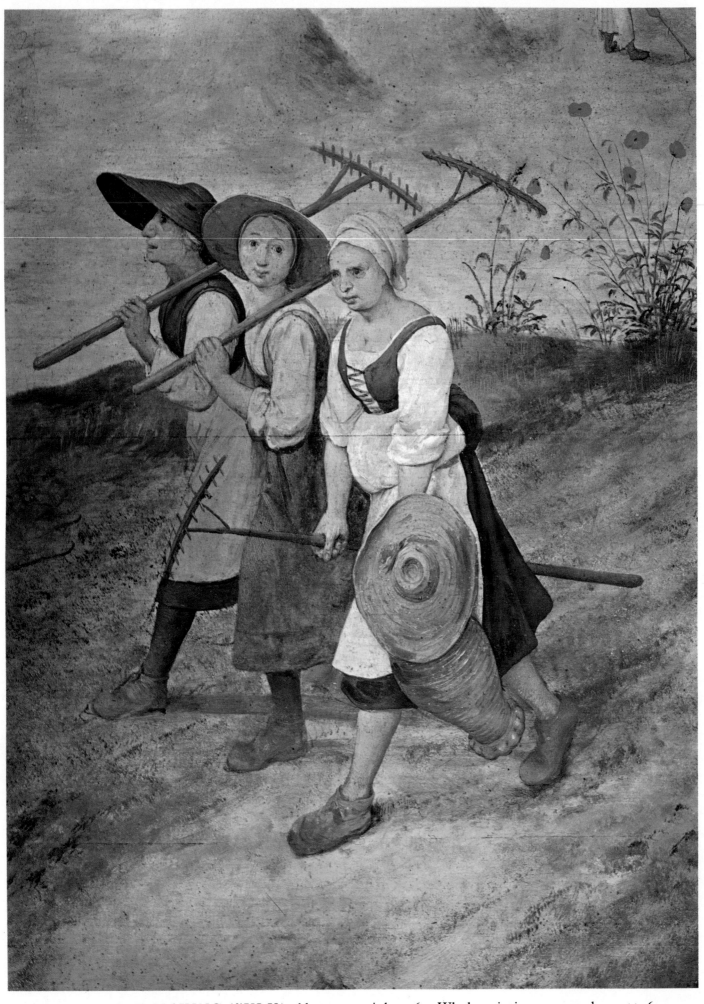

26. Detail from *HAY MAKING (JULY)*. Almost certainly 1565. Whole painting, on panel, 117 × 161 cm. Prague, National Museum

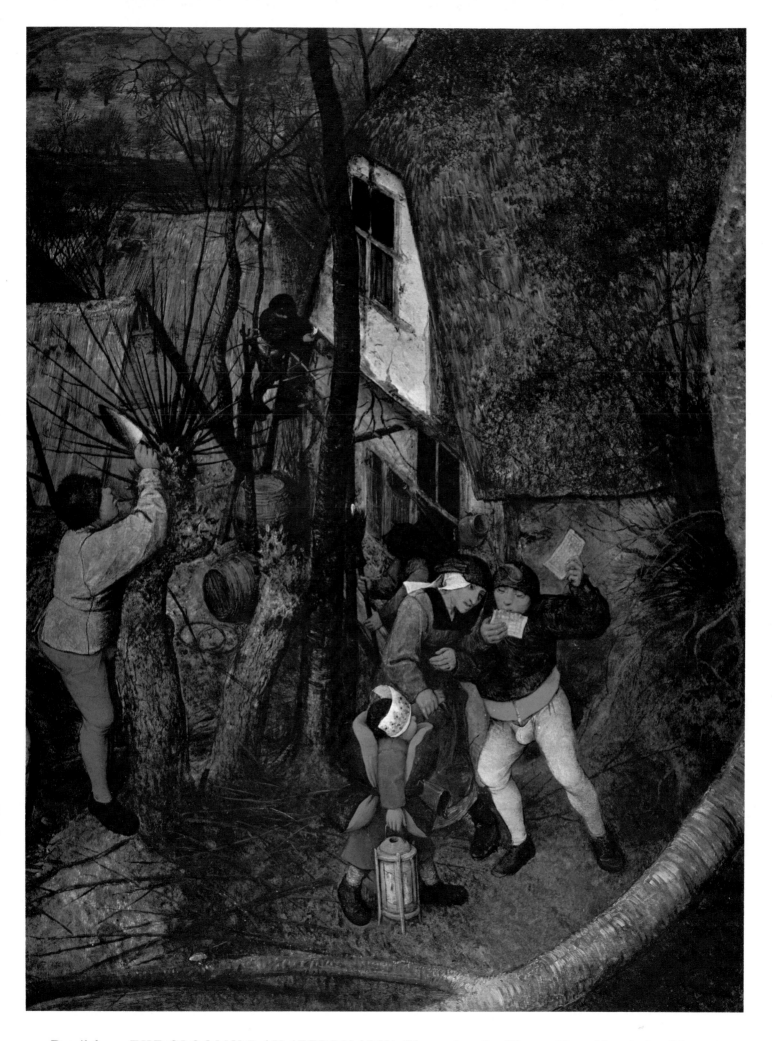

27. Detail from *THE GLOOMY DAY (FEBRUARY)* (Plate 22). 1565. Vienna, Kunsthistorisches Museum

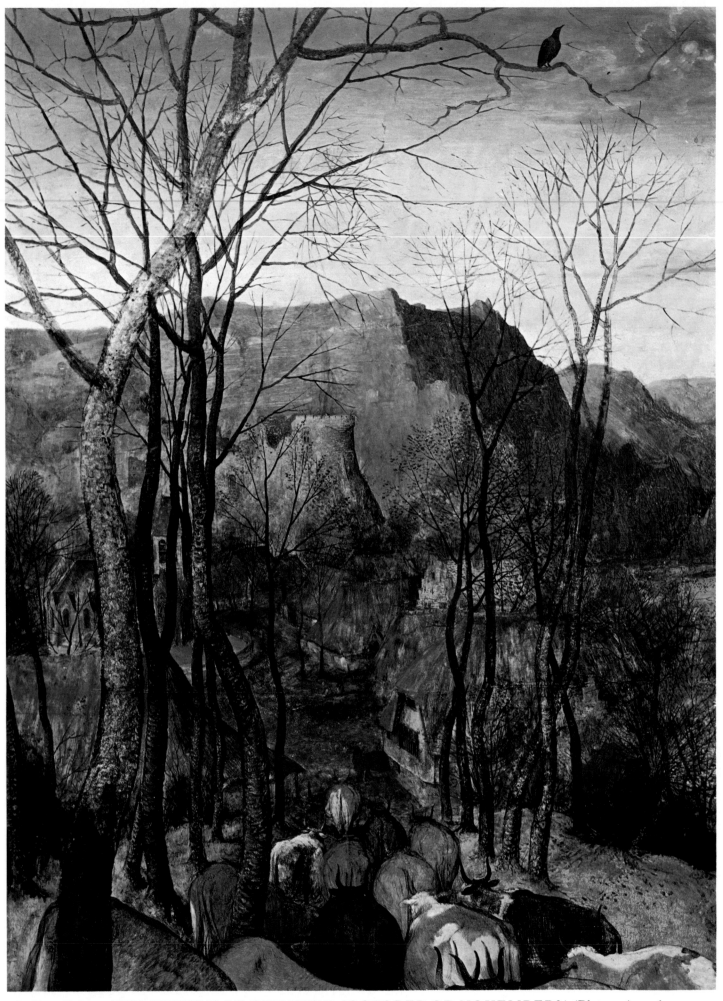

28. Detail from *THE RETURN OF THE HERD (OCTOBER OR NOVEMBER?)* (Plate 24). 1565.
Vienna, Kunsthistorisches Museum

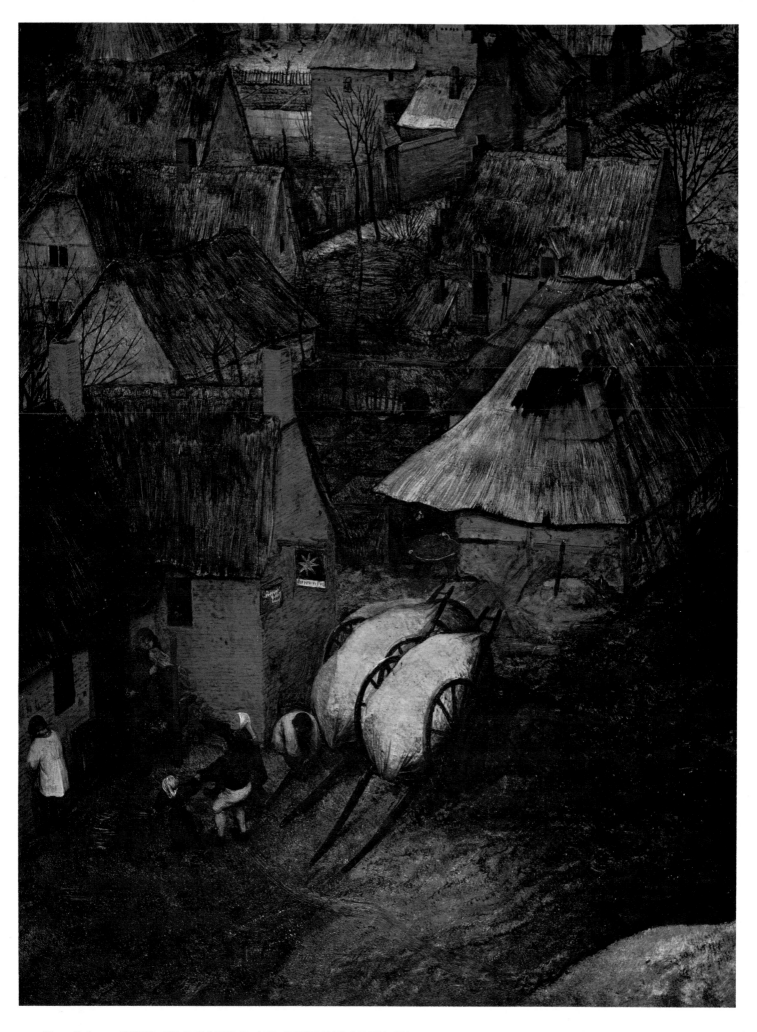

29. Detail from *THE GLOOMY DAY (FEBRUARY)* (Plate 22). 1565. Vienna, Kunsthistorisches Museum

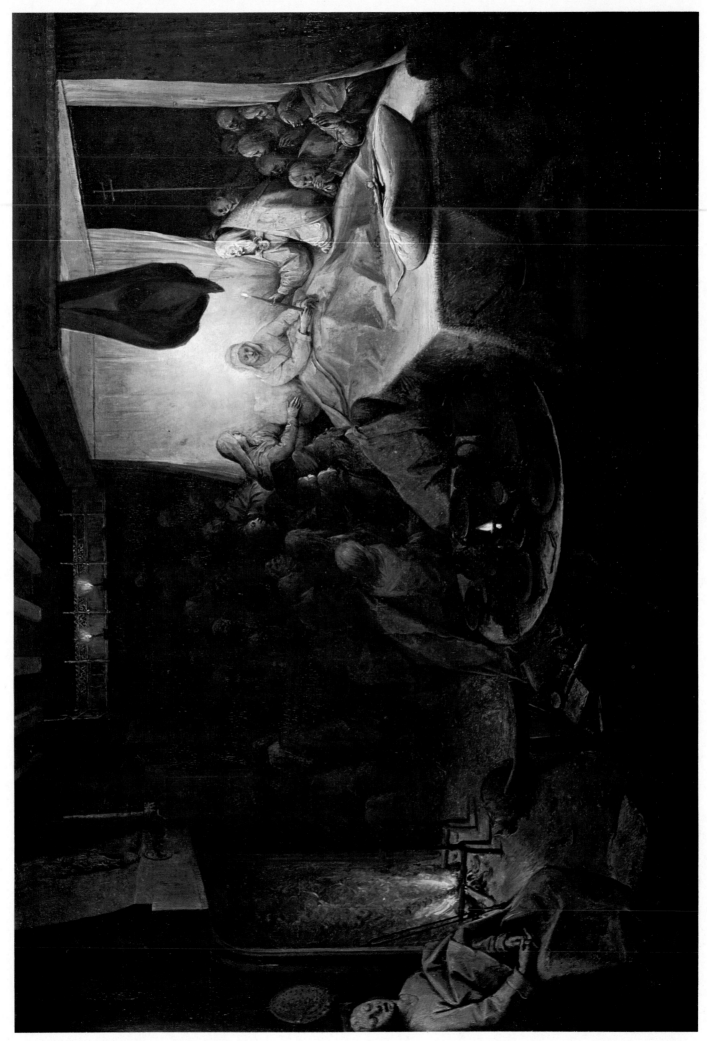

30. *DEATH OF THE VIRGIN*. Probably about 1564. Panel, 36 × 54.5 cm. Banbury, Upton House (National Trust; Bearsted Collection)

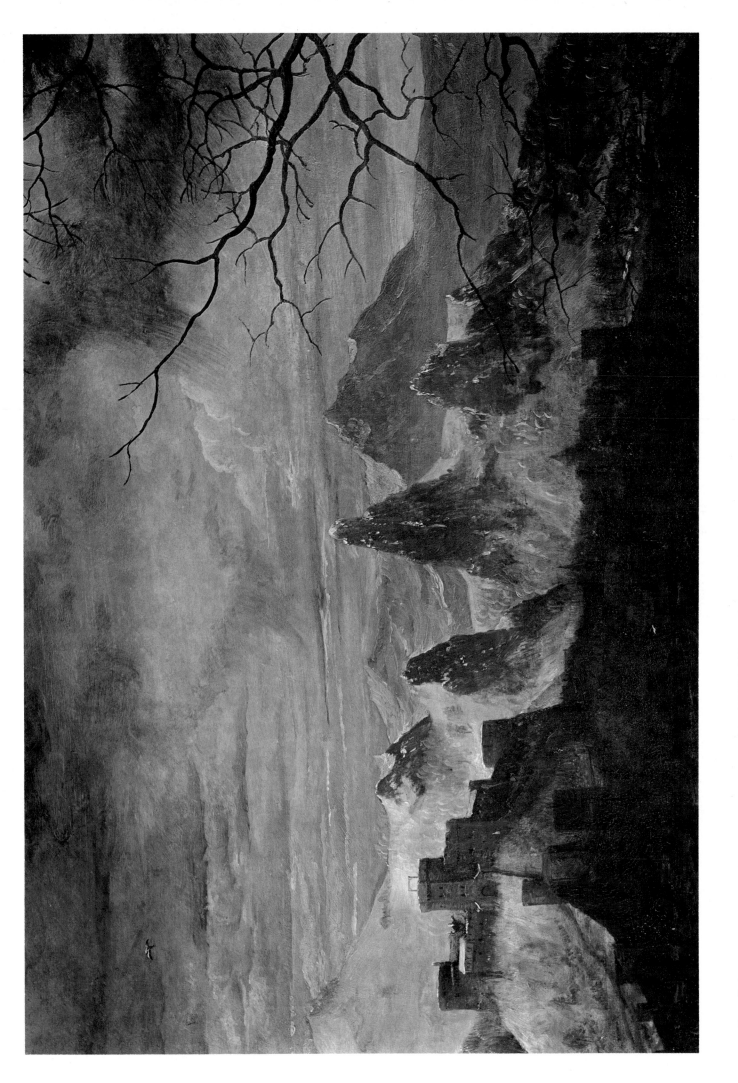

31. Detail from *THE GLOOMY DAY* (*FEBRUARY*) (Plate 22). 1565. Vienna, Kunsthistorisches Museum

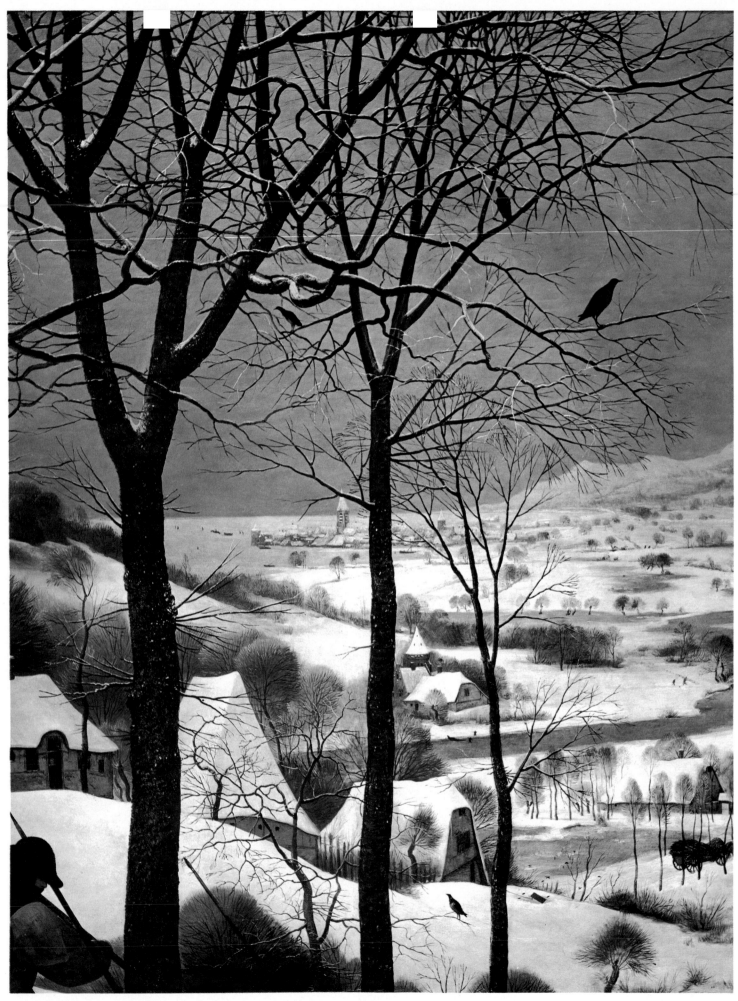

32. Detail from *THE HUNTERS IN THE SNOW (JANUARY)* (Plate 35). 1565.
Vienna, Kunsthistorisches Museum

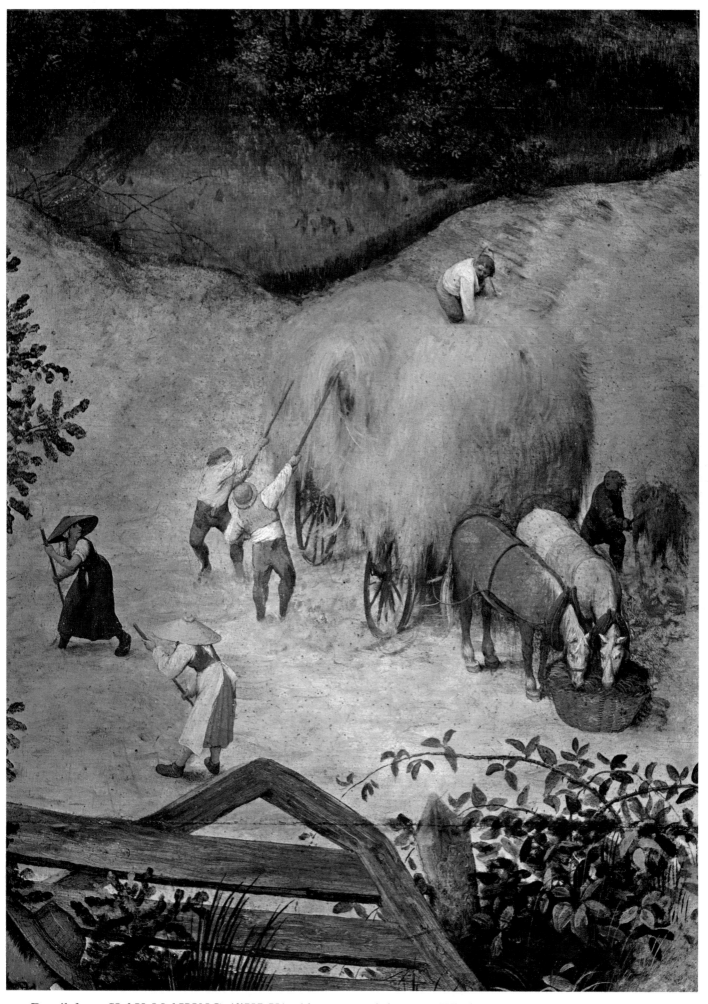

33. Detail from *HAY MAKING (JULY)*. Almost certainly 1565. Whole painting, on panel, 117×161 cm. Prague, National Museum

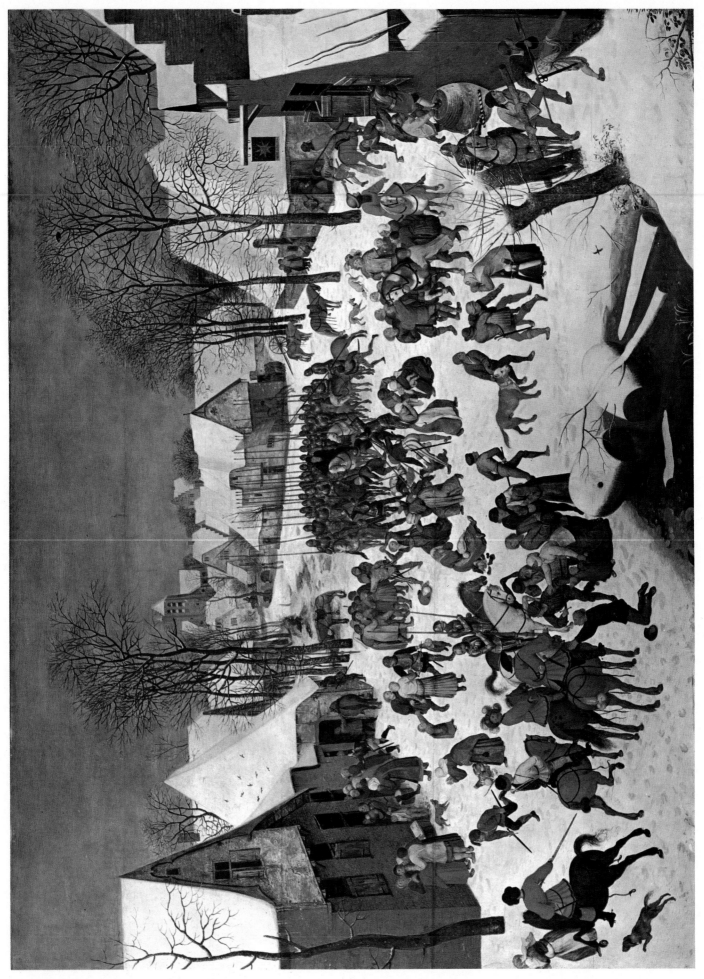

34. *THE MASSACRE OF THE INNOCENTS*. About 1566 (with studio assistance). Panel, 116 × 160 cm. Vienna, Kunsthistorisches Museum

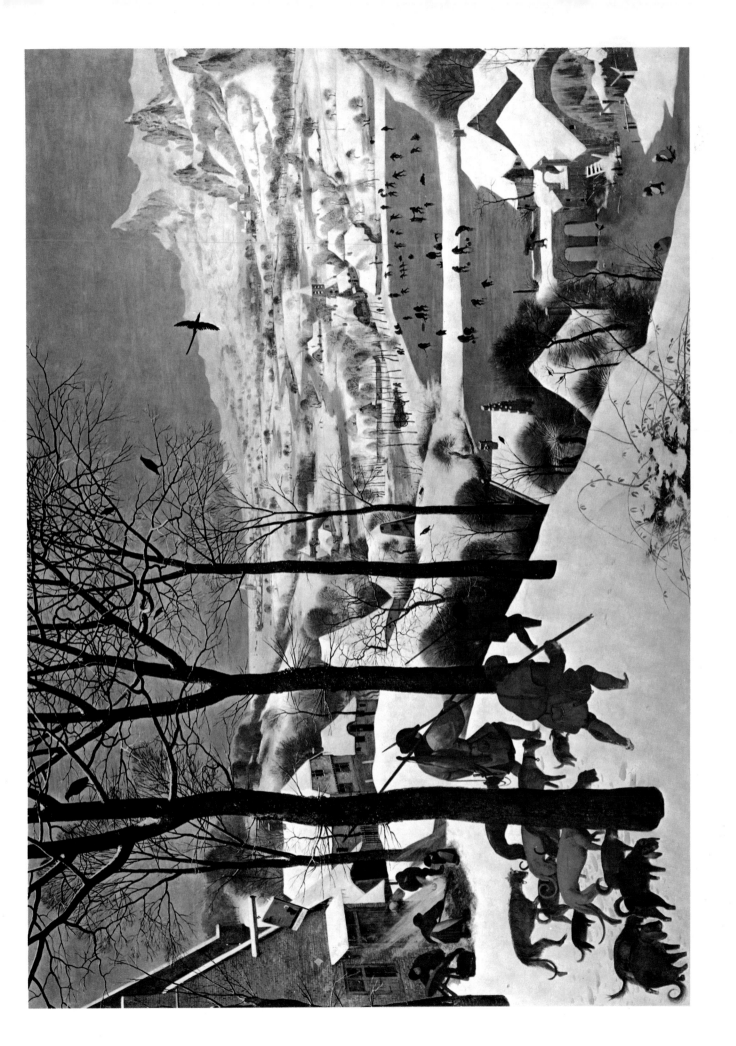

35. *THE HUNTERS IN THE SNOW (JANUARY)*. 1565. Panel, 117 × 162 cm. Vienna, Kunsthistorisches Museum

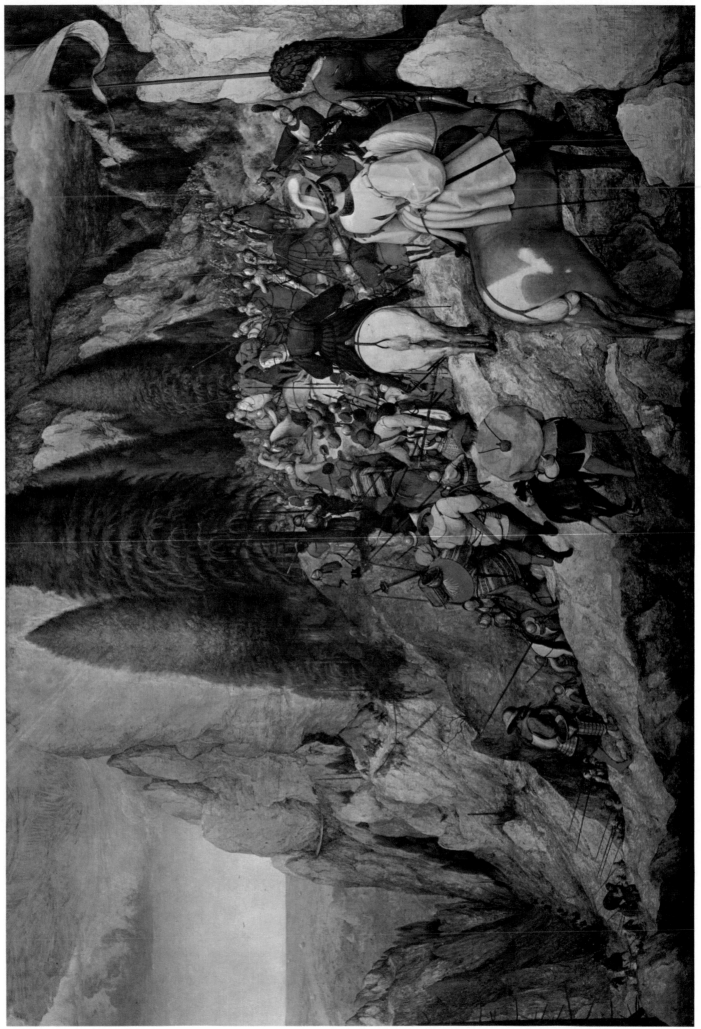

36. *THE CONVERSION OF ST PAUL*. 1567. Panel, 108 × 156 cm. Vienna, Kunsthistorisches Museum

37. *THE PEASANT AND*
THE BIRDNESTER. 1568.
Panel, 59 × 68 cm. Vienna,
Kunsthistorisches Museum

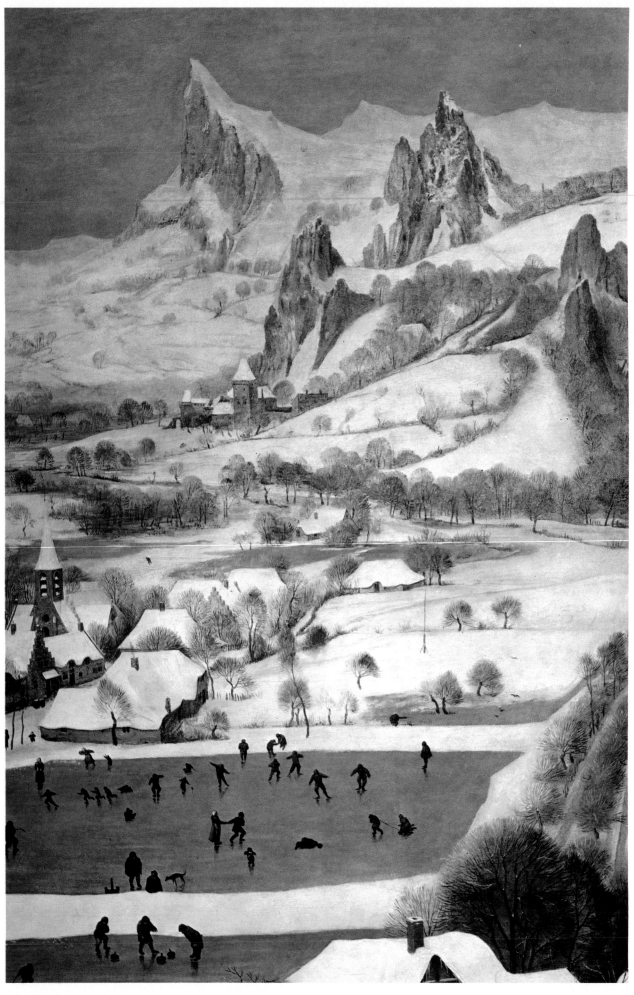

38. Detail from *THE HUNTERS IN THE SNOW (JANUARY)* (Plate 35). 1565.
Vienna, Kunsthistorisches Museum

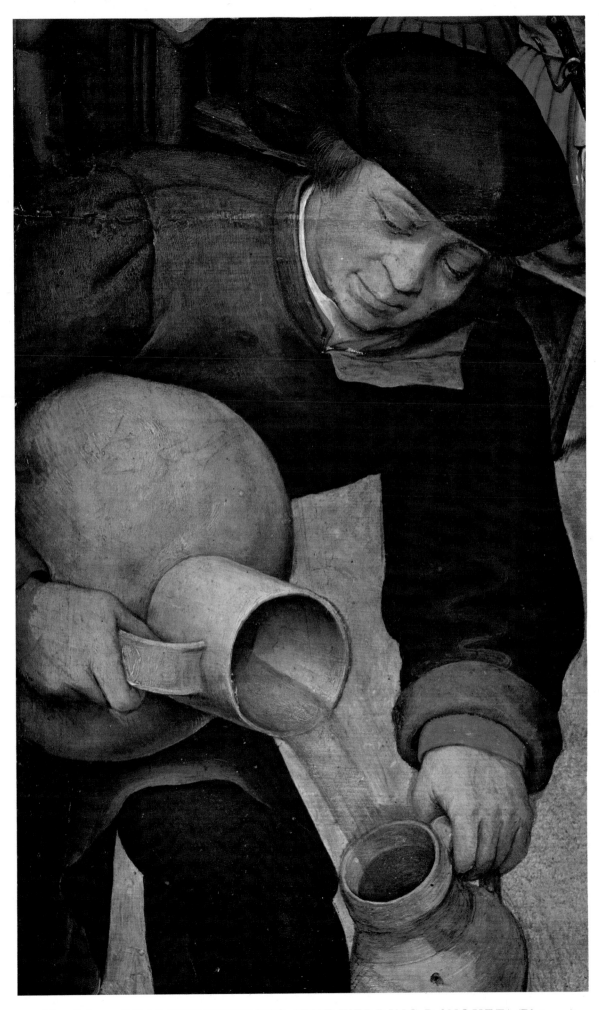

39. Detail from *PEASANT WEDDING (THE WEDDING BANQUET)* (Plate 40).
About 1567. Vienna, Kunsthistorisches Museum

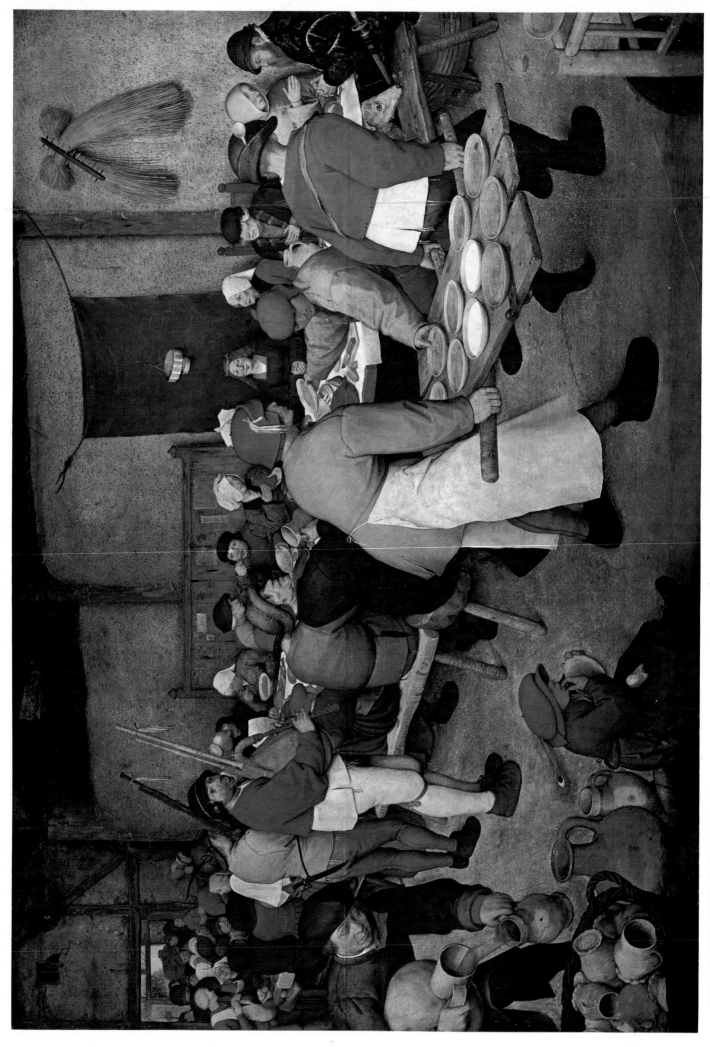

40. *PEASANT WEDDING (THE WEDDING BANQUET)*. About 1567. Panel, 114 × 163 cm. Vienna, Kunsthistorisches Museum

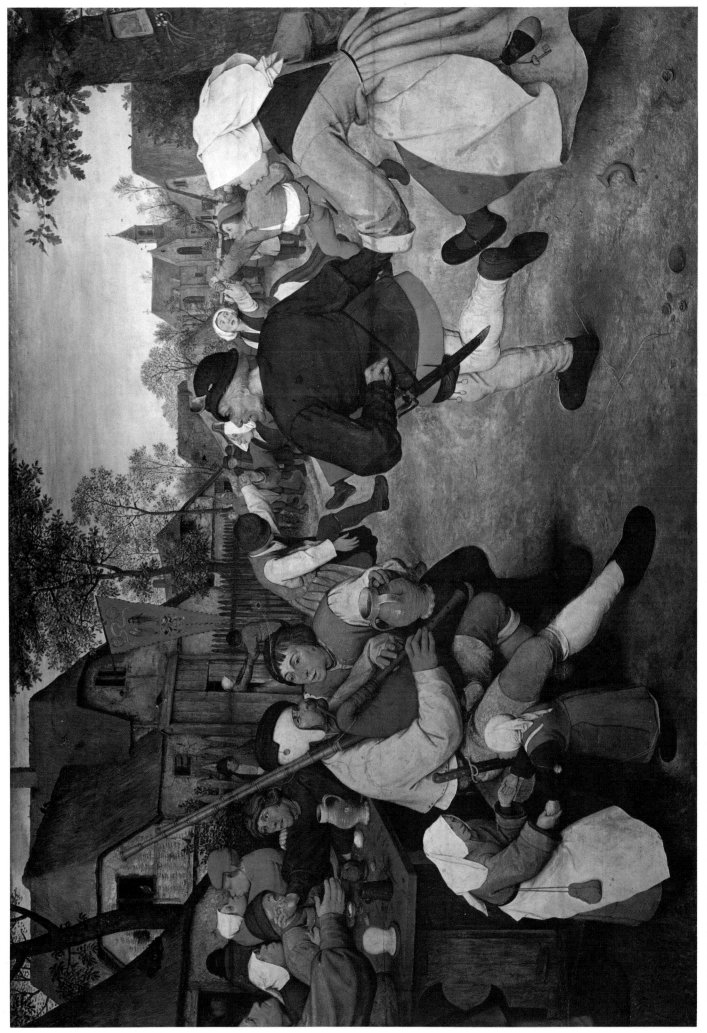

41. *THE PEASANT DANCE*. About 1567. Panel, 114 × 164 cm. Vienna, Kunsthistorisches Museum

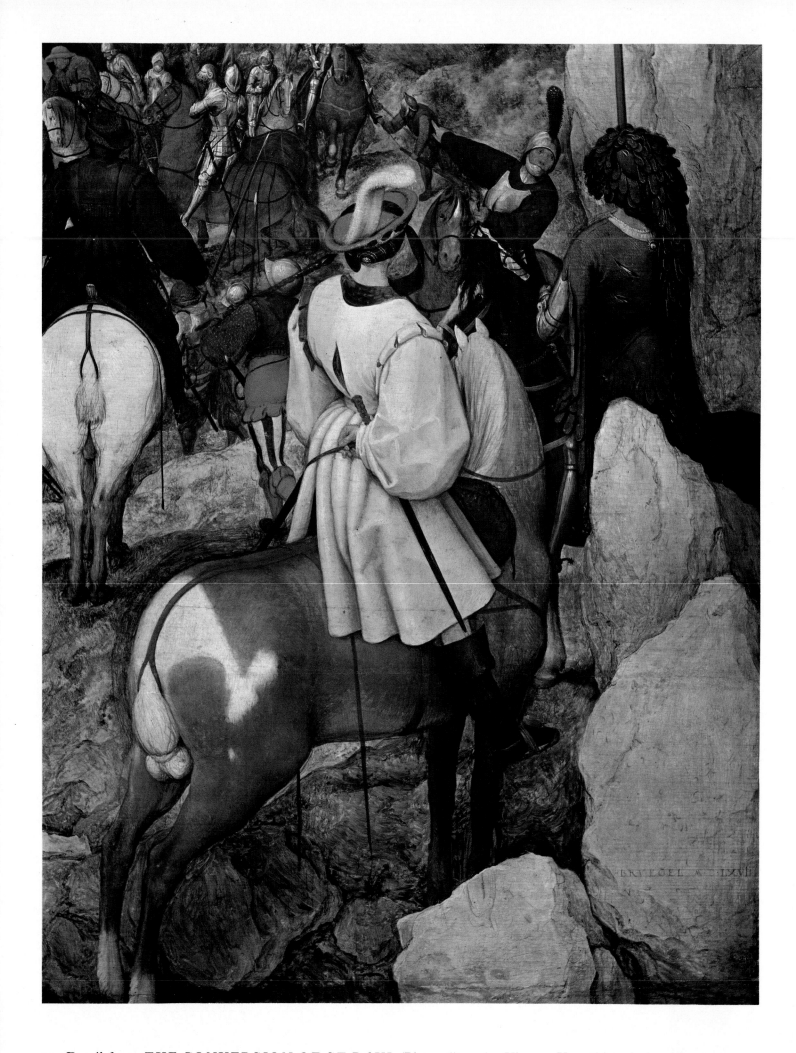

42. Detail from *THE CONVERSION OF ST PAUL* (Plate 36). 1567. Vienna, Kunsthistorisches Museum

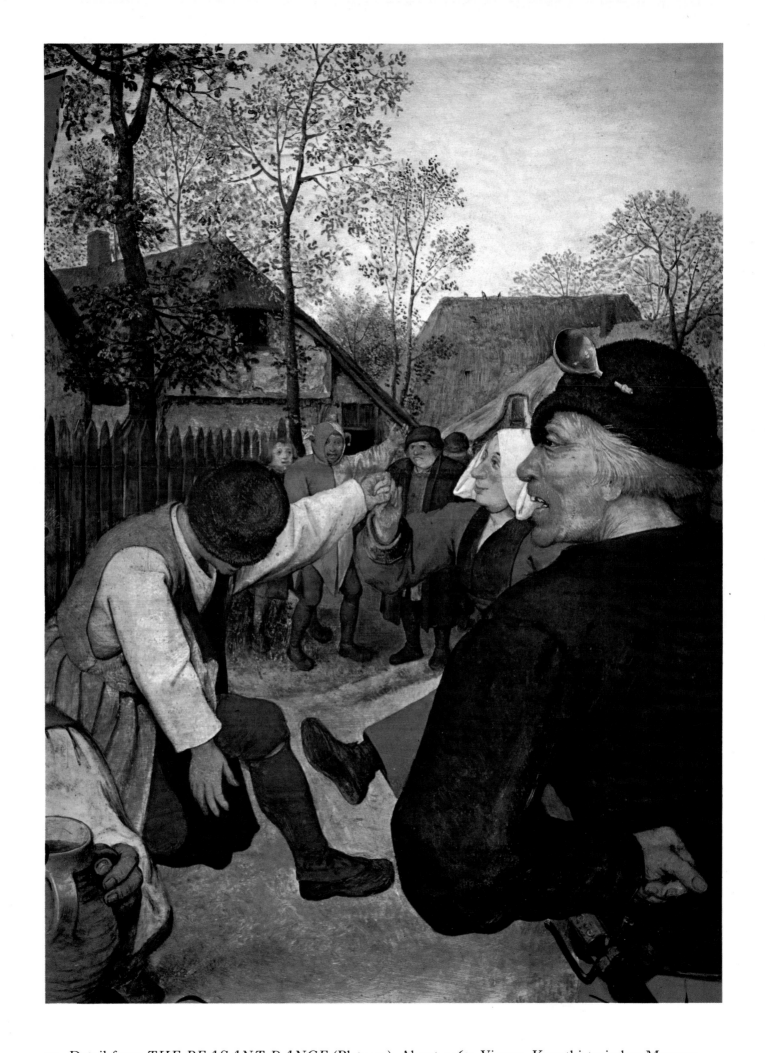

43. Detail from *THE PEASANT DANCE* (Plate 41). About 1567. Vienna, Kunsthistorisches Museum

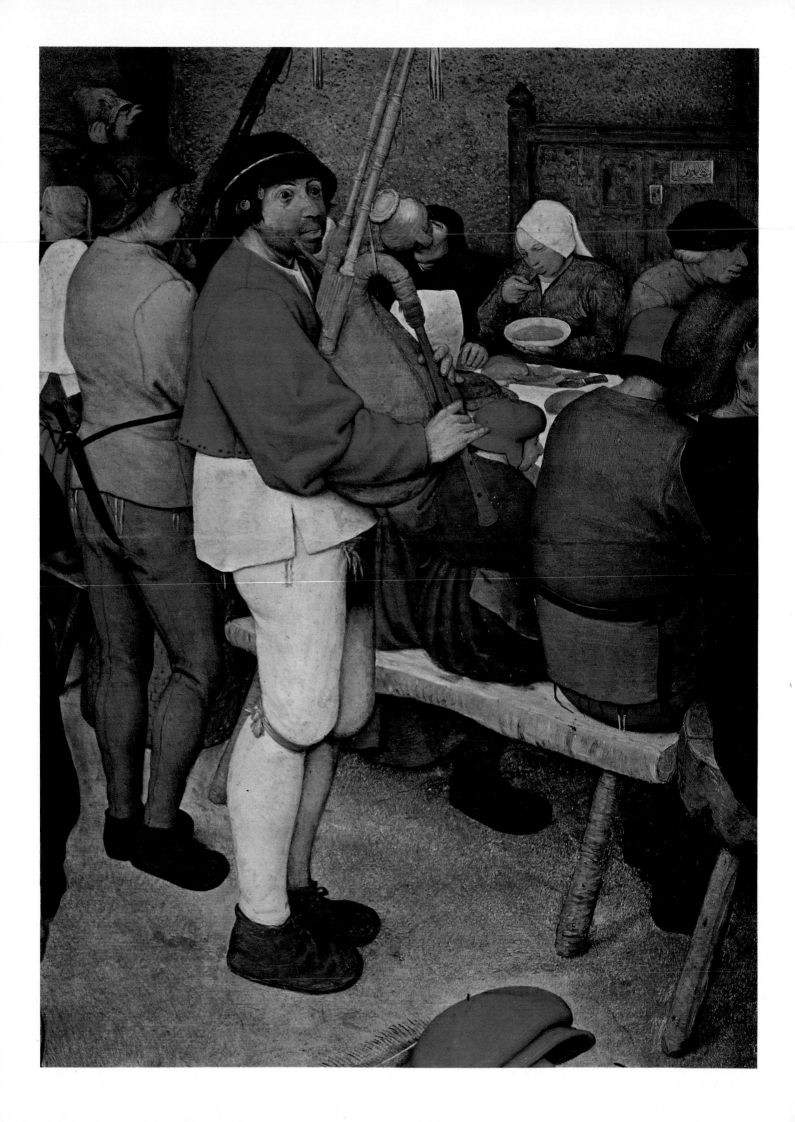

45. *THE PARABLE OF THE BLIND.* 1568. Canvas, 86 × 154 cm. Naples, Museo Nazionale

44. Detail from *PEASANT WEDDING (THE WEDDING BANQUET)* (Plate 40). About 1567.
Vienna, Kunsthistorisches Museum

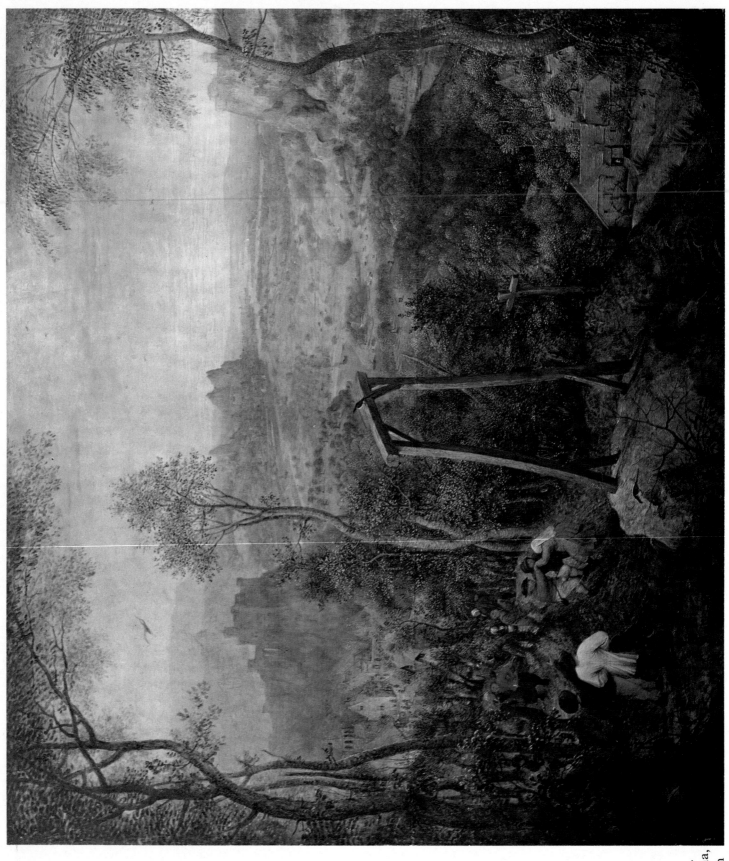

46. *THE MAGPIE ON THE GALLOWS.* 1568.
Panel, 45.9 × 50.8 cm.
Darmstadt, Museum

47. *STORM AT SEA.*
Unfinished. About 1568–9.
Panel, 70.3 × 97 cm. Vienna,
Kunsthistorisches Museum

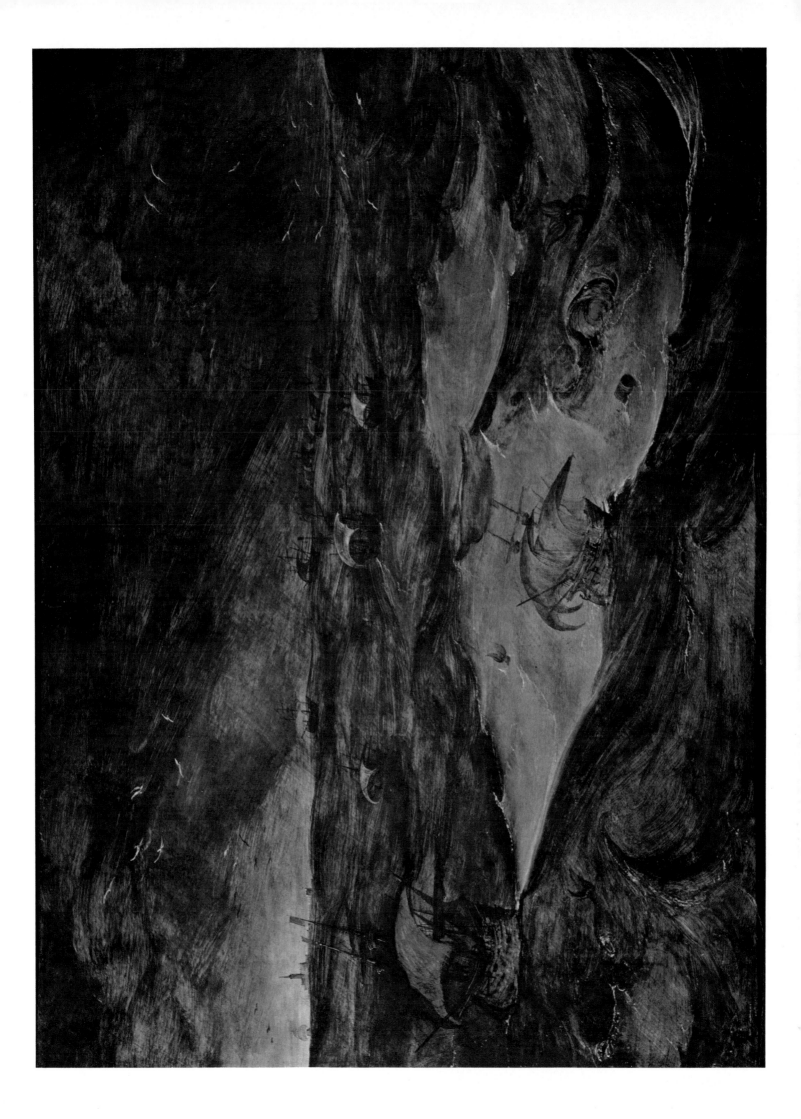

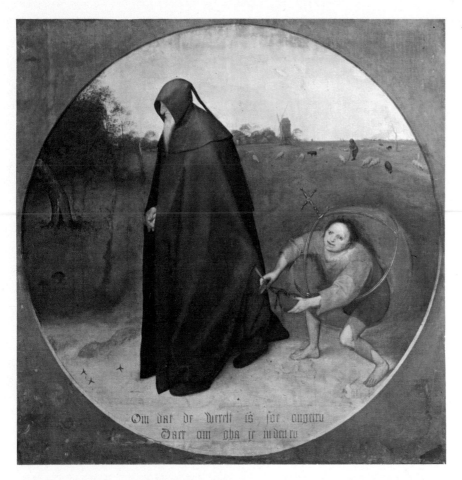

48a. *THE MISANTHROPE.* 1568.
Canvas, 86 × 85 cm.
Naples, Museo Nazionale

48b. Detail from *THE MISANTHROPE*

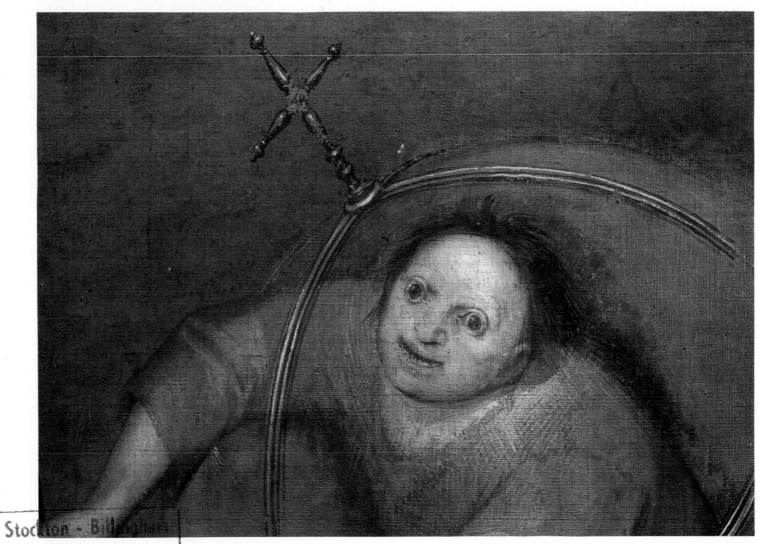